PARANORMAL
WILTSHIRE

PARANORMAL
WILTSHIRE

DAVID SCANLAN

AMBERLEY

First published 2009

Amberley Publishing Plc
Cirencester Road, Chalford,
Stroud, Gloucestershire, GL6 8PE

www.amberley-books.com

British Library Cataloguing in Publication Data.
A catalogue record for this book is available from the British Library.

ISBN 978 1 84868 461 4

Typesetting and origination by Amberley Publishing
Printed in Great Britain

This book is dedicated to all my fellow Ghost Hunters and Paranormal Investigators, sceptics and believers, everywhere, whose never ending dedication, enthusiasm and passion for the paranormal seems to know no bounds.

CONTENTS

FOREWORD

No matter what your belief regarding the existence of ghosts, the paranormal is a subject that continues to create wonder, fascination and debate for the whole world.

Even now in the twenty-first century, despite the advent of man's technological achievements in science we are still no closer to understanding the mysteries of the unknown.

Some say death is the end, others that it's simply a transition into another state of being. Whatever the truth may be, rest assured, we will all one day walk that inevitable path and come face to face with the ultimate answer.

But as we live our lives in the reality and comfort of physical being, could we be missing the clues embedded within the basic structure of many ghost stories? Could the truth be out there staring us in the face, willing us to recognise the in-dismissible evidence that life does go on and that some part of us really survives bodily death?

Sadly, the theories do not match our perception of our own reality, our here and now.

But should we really have the right to dismiss the possibility of life after death simply because such reasonings are unanswerable?

I think not.

Paranormal investigators and ghost stories go together like strawberries and cream, bacon and eggs, both separate, yet impossible to resist. Dave Scanlan is one of those investigators who do not give up the ghost simply because there is no evidence on his plate. To patiently search, question and adopt an understanding of what a ghost actually is should be every investigators mission statement and Dave's work is a perfect example to us all.

This, his second book brings together true tales of ghost sightings, hauntings and extraordinary accounts from the county of Wiltshire, a small part of the UK that like many others, all have strange tales to tell.

Andy Matthews
Paranormal and Psychic Investigator, Writer & TV presenter

ACKNOWLEDGEMENTS

The writing of a book obviously brings any author into contact with a great many people and I have been no different with the writing of this book and in my quest into the haunted realm of Wiltshire.

I would like to take the opportunity to pass my thanks onto everyone who has assisted me with the writing of *Paranormal Wiltshire* and in particular to Sarah Flight of Amberley Publishing who has been a great support, Rob Grist from Tadley, Andrew Marsay of Paranormal Tours, Adam Campbell from the King & Queen Inn at Highworth, Ordnance Survey – Southampton, The Longleat Estate, Tourist Information Centre – Corsham, Andrew Clarke, Dave & Karen Gray of the Harrow Inn at Wanborough, Emma Wright and the South West Paranormal Group, Hayley Stevens and the Wiltshire Phenomena Research Group, Paul Whitburn of the White House Inn, John Girvan of the Canal Forge at Devizes, Simon and Wendy Harrison, Roger and Petra Fessey, Andy Matthews for his very kind foreword and everyone else that has helped out along the way.

My final thanks must go to the investigation team of the Hampshire Ghost Club whose commitment to the 'hunt', and to me, has been truly outstanding.

INTRODUCTION

In 2009 I had my first book published, *Paranormal Hampshire*. Once the book was complete, and I could finally relax for a while, I realised that I enjoyed researching and writing the first book so much that when Amberley Publishing approached me to write a second book I jumped at the opportunity and decided to get to work on the manuscript immediately.

Paranormal Wiltshire is the result of that work and I don't mind admitting that I am particularly proud of this fresh new look into the hauntings of the amazing county of Wiltshire, a county that is only a stone's throw away from my own home county of Hampshire.

There is no doubt that Wiltshire heralds some fine hauntings, the ghosts of Littlecote Manor alone beg for attention, investigation and further research, and there is plenty to keep any intrepid ghost hunter or paranormal enthusiast going for many, many years.

When I embarked on my journey of discovery into Wiltshire's ghosts I wanted to establish, right from the start, that the book was not just going to be the same old stories but hopefully would also include many new and never before heard of hauntings. I hope that I have achieved this aim and give to you, the reader, a memorable book of spooky stories and ghastly ghosts.

One thing to bear in mind with this book....I have tried to only include the stories that I feel are the most plausible and therefore probably the most truthful, although there are exceptions to this where I hope to dispel some of the many more commonly held myth and legends that are thought to be true. Remember... every story contained within the leaves of *Paranormal Wiltshire* has had an eye witness who is usually a normal, level headed person, just like you and I.

If I have omitted any stories that you feel should have been included within this book then please do let me know, by contacting the publishers, and I will endeavour to include new stories, and make updates to existing ones, in future editions.

So please do read on as I guide you through the haunted county of Wiltshire.

HOW TO USE THIS BOOK

When I sat down to work out a format of content and design for this book it was apparent from an early stage that the best possible layout was to make it an easy to read style of book.

With this in mind I decided to structure the book around an easy to follow A–Z guide, this means that finding the story you are particularly interested in is simple to locate. There is no need for an index as everything is listed in an A–Z format and this allows you to pick up and put down the book as and when required; this is particularly useful when researching specific locations in general, but also aides in reading the book cover to cover.

A Gazetteer of Wiltshire Hauntings

A342, Between Weyhill and Devizes

If you should happen to be driving down the A342 and come across a lonely female figure walking along the road it is probably for the best if you just continue on your merry old way, for the lady is a road ghost.

Road ghosts. More commonly known as phantom hitchhikers, litter many of the roads in England and the most famous of which must be the ghostly wraith of a woman who has been spotted at Blue Bell Hill in Kent by many people for many years. The lady on the A342 does not mind if you don't stop and offer her a lift. People who have spotted her and continue on their journey are somewhat surprised when they notice the lady sitting on the back seat of their cars before promptly vanishing.

It seems that if this ghostly hitchhiker wants a lift from you, whether you stop to collect her or not, she simply takes the ride...offered or otherwise!

A363, Sally in the Woods, Bradford-on-Avon

The A363, a small A road winding its way between the counties of Wiltshire and Somerset, passes an area known as Sally in the Woods. This region is looked down upon from a tower known as Browns Folly, which was built in the mid-nineteenth century, and appears to be a very focal point for the hauntings associated with Sally in the Woods.

Who the ghost is no one knows, but there is no short supply of possible candidates. Local legend and urban myth runs amok around the woods and

explanations for the phantom woman, who has been seen crossing the road, and even hitching a lift from passing unsuspecting motorists, have been offered in their plenty. One story relates the tale of a gypsy girl who was locked in the tower, Browns Folly, with no food or water and ultimately died there, another states the ghostly woman could be attributed to a titled lady who fell from the tower whilst trying to escape. Could it be that, somewhere along the chequered path that history carves out, there was indeed a fatality connected to the tower but through the years the story concerning the death has become twisted and contorted and the true historical facts have long since vanished?

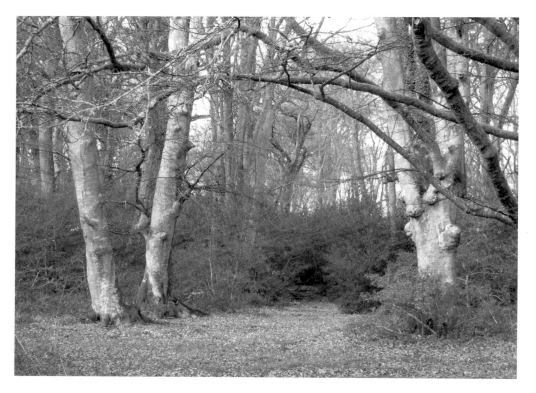

Unearthly voices and the wraiths of a mysterious woman and a boy all come together to make Sally in the Woods a classic ghost story.

Perhaps the ghost of the woman could be attributed to a fatal crash that happened here in years gone by. The A363 is a notorious accident black spot, so much so that in 2006 the local council's traffic and safety team implemented

a series of accident prevention schemes on the road which included reducing the speed limit and also bringing in an overtaking ban on the most treacherous parts of the road. Could the ghost be one of the passengers that lost their life in a most untimely fashion?

Regardless to the identity of the spectral woman, people walking the woods, and indeed people driving their cars past the woods, have reported a host of paranormal phenomena occurring in the area. Disembodied voices, the sounds of a baby crying, terrifying screams and the ghost of a small boy have all been reported. Sounds like the ideal place for a paranormal picnic, doesn't it!

AVEBURY MANOR, NEAR MARLBOROUGH

Looking at Avebury manor these days, with its classic sixteenth-century appearance, you would be easily led to believe that there was not much more of a deeper history connected to this house, you would be wrong. The house, although sixteenth-century, occupies the site of a much older, former monastic structure that was dissolved during the dissolution of the monasteries under King Henry VIII.

Avebury Manor is now in private hands but it is open to members of the public who are more than welcome to attend the house's guided tours that are conducted by staff members of the National Trust.

Having its roots in the monastic period means that at least one of the house's ghosts, that have been spotted here, is that of a monk. He was witnessed frequenting the library by the family's child-minder and although the lady could clearly see this monastic phantom, no one else present could. Eleanor Eaton, the current visitor service manager to Avebury Manor, told me that the ghost could very well be attributed to a monk who was allegedly killed here over 600 years ago after an argument with another monk. Eleanor also told me that a spectral coach, pulled by four ghostly horses, has also been seen in the area of the manor's gates.

The ghost of a lady in a white dress and the spectre of a Cavalier, thought to be that of Sir John Stawell who formally owned the house and lost all his possessions during the civil war, have also been spotted in various parts of the house and its grounds.

AVEBURY STONE CIRCLE, NEAR MARLBOROUGH

The stone circle at Avebury is a place of intense spirituality and has been used by mankind since prehistoric times; indeed it was our prehistoric forefathers that built the stone circle.

Over the years that the amazing, atmospheric archaeological remains have stood many people claim to have had a supernatural encounter at the site. The sounds of disembodied singing have been reported, small humanoid figures have been witnessed moving about the stones and one lady in particular, Edith Oliver, had a rather perplexing encounter. Whilst visiting the stone circle she suddenly became aware of a party taking place in the vicinity of the stones and when she moved closer, to illicit a more intimate inspection of what was happening, all the party goers had suddenly vanished into thin air. Were these the apparitions of the long since dead, a past life flashback or perhaps even a time slip?

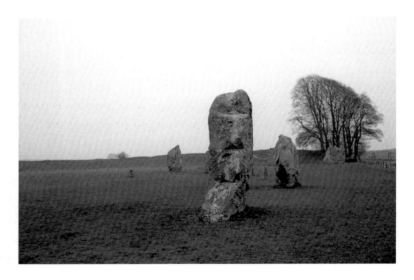

Avebury Stone Circle has been a significant place for our ancestors for thousands of years. The circle has laid witness to short spectral figures that have been seen flitting amongst the stones. Photo © Andrew Marsay.

Paranormal Investigator Andrew Marsay spent some time investigating the stone circle some years back. Andrew recalled "I remembered that although it was the summer there was a distinct chill in the air when we decided to start our investigation at the ancient Avebury Ring. We decided to start off here as

we'd read reports of strange mystical lights that been seen dancing around the stones, possibly ancient spirits being associated with them. It was my interest to see if there was any truth in this. We strategically placed ourselves around; I had my back to the church that connects to the field, facing the circle. Our medium for the night asked for any energies present to show themselves as we were inquisitive to know if they were with us. A short time passed with no results when all of a sudden I felt a sudden 'kick' through my right ankle and carry on through to the other side and then hit my left ankle, unbalancing me to the point of nearly falling over. I have no idea what had hit me, however, our medium could see small 'elemental creatures' dancing around in the darkness and gave a little chuckle! Personally for me, I don't know what it was that hit my ankles, all I know is that for some unknown reason both my feet where kicked away from me coinciding with what the medium said he saw."

Was Andrew's experience due to paranormal influences or something more mundane and explainable?

Black Swan Hotel, Devizes

The Black Swan Hotel, in the Market Place at Devizes, is a hotel renowned for its supernatural activity; in fact the current landlords even host numerous ghost vigils every year for paranormal investigation groups from around the country, which gives many people the chance to experience the ghosts of the hotel first hand.

With so much publicity surrounding the hotel's haunting I decided to contact the owners to see if they could throw some light onto the subject of the ghosts and tell me about their own personal experiences whilst owning the Black Swan. Pam Lugg, the current owner told me, "when we first moved into the hotel we were told it was haunted by a girl and a man and there certainly has been some interesting things going on during our ownership of the hotel".

Intrigued at what Pam has experienced here I pressed for more information and Pam continued: "We hear the chairs moving on their own in the function room, footsteps, you can hear the click of the latches as the doors open and close and they are really heavy doors and close well, so its not draughts moving them. People have also seen a shadowy figure that moves past the reception area and then heads down the stairs to the cellar".

It appears to be both the function room and the cellar that holds most of the hotel's ghostly goings on and Pam took the opportunity to tell me about a

vigil that was held recently in the function room. "There was this man on the vigil and he was dressed in a plain black T-shirt and all of a sudden he started to complain that he was feeling ill and very uncomfortable. We all turned our video cameras on to him to see what was going on and there were these sparkles that were coming out from his chest. We didn't have any idea of what could be causing these sparkles so we decided to stop the vigil as, by this time, the man was not feeling very well at all."

One of the professed forms of ghostly evidence put forward by investigators these days is the phenomena of orbs, small balls of light that people often associate with paranormal experiences. The Black Swan has had its fair share of orb photographs but is also the home to a variation of the orb debate . . . square orbs!

Ghost Hunter Bob Hunt captured these orbs during an investigation at an allegedly haunted pub, but are they really evidence that ghosts exist? Photo © Hampshire Ghost Club.

The hotel certainly has had some strange occurrences happening within its four walls and I have no doubt, in at least my mind, that Pam has experienced all of what she has told me, she is, after all, a very down to earth person who is always looking for a rational and plausible explanation.

Pam is soon to leave the Black Swan and move onto pastures new . . . to yet another haunted pub. The Kings Arms in Melksham, their haunting story is also featured in this book.

Box Hill, Box

The parish of Box, five miles east of the city of Bath, has its claim to fame for fine stone. Past civilisations have extracted and worked stonework here for centuries and some of the earliest evidence of this comes in the form of a flint tool working site from the Mesolithic period of history.

Today the small parish is noted for its Box Tunnel which was designed for the Great Western Railway by the famous industrial revolution engineer, Isambard Kingdom Brunel (1806–1859). Past workers on the train tracks and engineers servicing the tunnel have stated that they don't particularly like working this area of track. Employees over the years have claimed that the sounds of an approaching train ring out and although the workers scan the area for the culprit, no trace of any train can be found. Who knows where the phantom train is going or for how long it will travel the tracks through the village of Box?

Bull Lane, Kilmington

If you happen to be making your way down Bull Lane, in Kilmington, be mindful of the phantom that you may encounter down here.
The ghost of a horse, of which some witnesses claim it to be headless, has been witnessed haunting the lane. Where it comes from and why it's here, or more interestingly why it is headless in the first place, are all questions that I think will never be answered to a satisfactory level.

I feel at this stage that I should make it known, that despite my best attempts to verify and confirm this story . . . I can't! I have searched the entire area for Bull Lane but it simply does not exist. The Ordnance Survey, based in Southampton, has informed me that they also have no current records of such a place. It could be that Bull Lane is a now disused lane and not marked on maps anymore but

it could also be that this story is simply a legend and should be put to rest so that serious research into real hauntings can continue.

CANAL FORGE, DEVIZES

John Girvan is no stranger to the paranormal, he has been researching and investigating ghosts and mysterious places now for many, many years and recently got increased exposure, surrounding the haunting of his forge in Devizes, after a visit from the Living TV show, *Derek Acorah's Ghost Towns*.

John is well known in the local area for being a historian of some note, a paranormal enthusiast and investigator, the author of numerous books and also as the guide of the Devizes Ghost Walk. He is without doubt one of the most knowledgeable people on the ghosts of the immediate area.

I spoke to John about the Canal Forge; a fully functional forge that is still in use to this day, for the place has had a somewhat remarkable catalogue of paranormal events occurring here over many years.

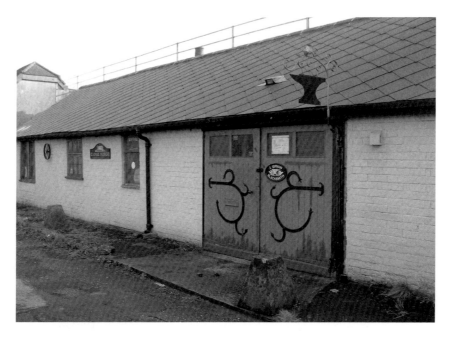

The Canal Forge at Devizes. Its ghostly occupants are somehow connected to the place via a mysterious wooden crucifix that was found imbedded in a wall! Photo © John Girvan.

"When I first took over the forge in 1982 it was not long before I noticed that there was this loose stone in the wall that protruded out a little. After a while I removed the stone with the aim of reseating the stone in its correct place. When I removed it I found a small wooden crucifix nestled in the wall. I showed a medium the cross and got told that it was placed there to protect the forge from unwelcome spirits. Since that time we have had quite a few mediums come here and many of them claim to have sensed the souls of numerous people."

So has the forge always been a forge? "No. Before I turned it into the current forge it was used as a workshop for the long gone gasworks and prior to that the area was used for breaking stone." Perhaps it is the ghost of one of these former workers that now haunts the site.

A large bright orb photographed at the Canal Forge in Devizes. Is this proof of the paranormal or something more natural in origin? Photo © John Girvan.

"I have also had psychic artists in here who say they can draw pictures of the dead people that haunt the forge. Two of the pictures are very similar in their appearance and both show the image of a bald man. The most interesting occurrence of late was when Derek Acorah came here with his show *Ghost Towns*. He took hold of the crucifix and then became possessed. He was shouting and screaming at someone we couldn't see and then he collapsed."

Many photographs have been taken by intrepid investigators of the paranormal and John says that literally dozens of pictures of orbs have been captured in here. Are the orbs a sign of a ghostly presence or are they just particles of dust, moisture and insects that have become illuminated in the flash of oh so many cameras? You will have to decide on that one for yourself.

John's forge certainly has some interesting history and some even more interesting ghostly tales to tell, if you would like to experience the haunting of the Canal Forge for yourself then John is happy to hear from you as he hosts vigils at the Canal Forge on a regular basis. You can discover more by visiting John's website at www.devizestours.co.uk.

CANAL TAVERN, BRADFORD-ON-AVON

This charming little pub lies on the banks of the Kennet and Avon Canal, a canal system that runs for some 57 miles between Newbury in Berkshire and Bath in Somerset and which has been in use for over 250 years.

Looking across the peaceful canal and the pleasant surroundings it is not hard to imagine why the ghost of the Canal Tavern still lingers here. Many claim the spectre of an elderly gentleman, who has been seen sitting in what is now the pub's kitchen quietly puffing away on his old-fashioned clay pipe, is the soul of a departed past landlord.

Victoria Kisioglu, the Canal Tavern's most recent landlady, only took over the pub in the early months of 2009 and has to date "yet to experience anything paranormal". Giving Victoria's relatively short time at the tavern perhaps that is not so surprising but who knows what the future may hold, "I would love to see the ghost to be honest with you, it's all very exciting. When I took over here I was told the pub had a ghost and that the bottom of the stairs was home to a very strange cold spot. I have stood by the stairs frequently but am also yet to experience this".

CROSS GUNS, AVONCLIFF, BRADFORD-ON-AVON

This picturesque pub, sitting on the Kennet and Avon Canal, is a very popular pub, and so it should be with its great food, fine ales and spirits, interesting history and of course . . . its spooks and spectres!

The Cross Guns was not built all in one go and virtually every visitor can notice the very subtle changes that periods of extension brought to the pub. The main part of the building originates from the 15th century and later additions being made with the construction of the east wing in the 17th century followed by the addition of the west wing in the 18th century. The pub was originally known as the carpenters arms, however, this changed when the 9th battalion of the Wiltshire Rifle Volunteers were created and took the area as their home. With a strong connection to the military the pub changed its name to reflect its associations with the regiment and became The Cross Guns.

But what of its ghosts I hear you ask. Well there are three spectral inhabitants residing in this idyllic little pub. The ghost of a woman who appears to be dressed in blue has been reported as has our classic spectral friend, the grey lady. The apparition of an elderly gentleman has also been reported. Things are pretty quiet at the pub these days, spiritually speaking, but the renovations that took place at the Cross Guns in 2004 did seem to enhance the supernatural activity at the pub, for a short while at least!

DEBENHAMS, BLUE BOAR ROW, SALISBURY

The popular department store of Debenhams is not the usual place you would expect to find a resident ghost, but a ghost it certainly has.

The shop, which sits in Blue Boar Row, occupies a site where once a public house stood, the Blue Boar Inn, which is where Henry Stafford, 2nd Duke of Buckingham (1455–1483) spent his last night before being taken for execution.

Stafford was executed for rebelling against King Richard III, a monarch he had formally supported. So great was his support for the king it is even said that Henry may have been the one who murdered the two young princes, Edward V (1470–1483) and Richard of Shrewsbury (1473–1483), who became famous for their imprisonment, and subsequent mysterious disappearance, in the Tower of London. With their deaths, plus the boys being declared illegitimate, Richard III was able to seize the throne of England. It may have been the conscience of

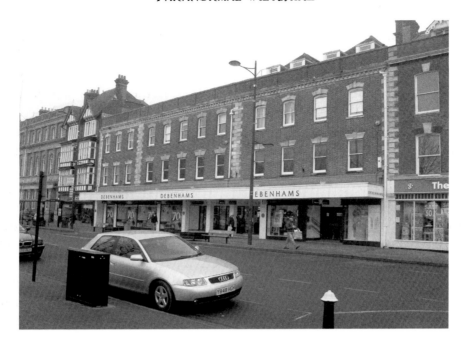

Debenhams department store in Blue Boar Row, where the ghost of the executed Duke of Buckingham has been seen.

the Duke of Buckingham that made him change his support from Richard III to Henry Tudor, having the blood of two children on your hands is something most people could not bear.

By changing allegiances Stafford had sealed his own fate. He was arrested, charged with treason and executed in Salisbury, his bleeding, severed head being brought forward for inspection by the King who was resting in the nearby Cathedral Close. The phantom blood splatters from the oozing decapitated head can, allegedly, still be seen to this day mysteriously appearing along the route his head took to the King.

People over the years say they have felt an invisible hand touching them whilst they go about their daily business in the store and a select few have even seen the headless wraith of the Duke himself, haunting the store.

DEVIZES CASTLE, DEVIZES

The site that the current Devizes Castle now occupies has a relatively recent appearance as it was constructed in the Victorian era, however, the original

castle which stood here, that was a simple motte and bailey type, was erected in 1080. Tragedy struck the castle in 1113 when a fire tore through the building but it was rebuilt, this time using stone, in 1120. The castle thrived for many years until the Civil War came to Devizes and in 1648 the castle was demolished by the victorious Parliamentarian forces.

The castle was rebuilt in the 1800s and is now divided up into a series of private apartments. The castle is not open to members of the public so please do not turn up expecting to have a look around.

There is quite a plethora of ghosts that haunt here and with people actually living in the building its not surprising to find that eye witness accounts get reported quite frequently. One former resident often used to see the apparition of an elderly lady, walking with a cane, moving around in the hallway. The gallery is meant to be particularly haunted by unseen presence. The only way that the living can tell that something untoward is occurring is by watching the reactions of dogs. Animals are meant to have a much more in tune psychic sense than humans and can detect ghosts in many haunted places, although there is no scientific proof of this.

Probably the most jaw dropping encounter is the time a resident not only saw one of the castle's ghosts but actually walked right through it. The lady, who was setting off for bed, ascended the staircase and came face to face with the ghost of a Cavalier dressed smartly in his full regalia of a feather plumed hat, beard and sword.

In 1396 a young French lady by the name of Isabella of Valois (1389–1409) came to Devizes Castle. Isabella married the king of England, Richard II (1367–1400), being only six years old at the time of her marriage, which was obviously for political reasons. Legend tells us that Isabella took a lover and when the king discovered the treachery he had the young lady bricked up in a wall whilst she was still alive. It is meant to be the spirit of the young Isabella that has been seen pacing up and down the confines of the castle. There is a small problem with this story though. The fate of Isabella of Valois is well known and therefore the story of her being bricked up alive cannot be true. Following the death of Richard II, Isabella returned to her native France and married one of her cousins, eventually dying in childbirth in 1409, aged only nineteen-years-old. This means the legend of her dying in such a horrific manner is obviously incorrect, but it does leave us with the question as to the real identity of the ghostly girl that has been witnessed at the castle and also to question where the legend of a woman being bricked up alive in a wall of the castle originates from?

Our final spooky phenomena that occurs at the venue is the sound of disembodied voices, voices that are attributed too two soldiers who were stationed here during the Second World War and were forced to sleep in the corridors of the building due to their incessant sleep talking.

DRUMMER OF TIDWORTH, TIDWORTH

Sitting ten miles west of Andover lays the growing town of Tidworth, a place that has become synonymous with an extraordinary haunting in the 1600's.

A vagrant by the name of William Drury is at the very heart of the haunting. In 1661 Drury pestered the neighbouring village of Ludgershall with his incessant banging on his drum. His aim was to so annoy the people of the village that they would pay him to go elsewhere. His plan failed when a local magistrate, John Mompesson, became so enraged at Drury's action he had him arrested and seized his infernal drum.

Drury's seized drum had been sent to the Mompesson home for some unknown reason in the meantime. When Mompesson returned home from a trip to London his wife regaled him with stories of the terror they had experienced whilst he was away. Mompesson was to experience his own fair share of frightening experiences. A whole host of events took place over the next two years which included bangs and knockings on doors which when they were answered jumped to other doors, chamber pots being emptied in to the families' beds, ghostly figures with red eyes were seen moving around in the home, disembodied voices were heard screaming "a witch, a witch", objects were thrown around and at the family members and their friends, money turned black, beds levitated into the air, candles floated up the chimney stacks, unexplained blue lights were witnessed flashing about the house and the most unusual phenomena was discovered when Mompesson's horse was found on its back with its leg rammed firmly in its mouth!

All of these phenomena obviously created much interest and the site was investigated by Joseph Glanvill (1636–1680). Glanvill has often been termed as the earliest scientific based ghost hunter and despite his best attempts he could never find an explanation for the occurrences that transpired within the family home.

William Drury, for some of the time that the supernatural happenings were occurring at the Mompesson House, was serving time in Gloucester Gaol for theft. It was during this time that Drury claimed he had been the one who had

terrorised the family through the use of witchcraft. He was tried for witchcraft but cleared of the charges, which in no doubt saved him from execution, however, he was deported but somehow managed to find his way back to England. Upon his return to British soil the phenomena, that had stopped occurring at the Mompesson house, started again but faded out relatively quickly compared to the first session of events. What became of Drury and his drum no one knows. Drury is long gone . . . his drum may well still exist but where could it be and how could it be proved that it was indeed his drum, even if it was found?

ERLESTOKE PRISON, ERLESTOKE, DEVIZES

This category C prison, which occupies the land on which a manor house once formerly stood, can boast the title of the only prison in the whole county of Wiltshire.

The former manor house, built for MP Joshua Smith (1732–1819), was badly damaged in a fire that broke out in 1950 and afterwards the decision was made to convert the grounds into a prison. The ghost that haunts here is currently unidentified and it's not known if the ghost originates from the area's time as a prison or from its former life as that of a manor house.

What is known is that a spectral woman has been witnessed entering the prison through a wall and is then seen to be inspecting the cells before vanishing through a different wall.

HARROW INN, WANBOROUGH, SWINDON

This idyllic thatched pub, frequenting the edge of the Marlborough Downs, has its roots firmly footed in the seventeenth century and has always been a place of refreshment and rest.

The Harrow retains many of its original features, including a rope and pulley system for winching patrons, who had consumed too much of their favourite tipple, to the bedrooms above so they could sleep it off . . . how's that for customer service? Another of the pub's strangest features is that of the 'Dog Grate'. This is a small cage which, powered by the dogs frantic scurrying around inside it, caused a fan to be rotated above the fireplace and therefore provide the necessary air circulation in order to get the kindling of the fire to take. The

animal would have been removed before the fire ignited fully, probably explains why you won't find any ghostly hounds in this pub.

The ghost that is commonly associated with the pub is that of old Marlow. Marlow was a driver of one of the many stage coaches that use to frequent the Harrow and it is said that one day he lost control of his coach and horses and crashed just outside the inn. His restless wraith is meant to haunt the pub to this day, wandering the building at night in his eternal search for his lost passengers.

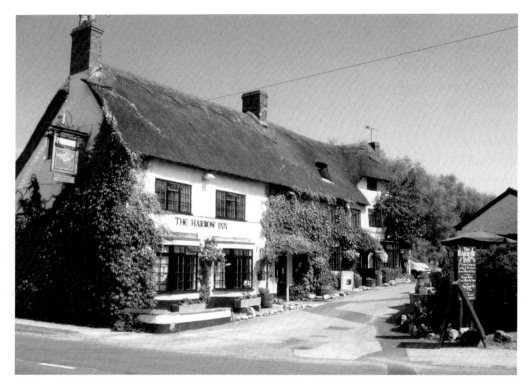

Has the use of a pendulum at the Harrow Inn revealed more of its spectral secrets than previously known? Photo © David & Karen Gray of The Harrow Inn.

Desperate to discover more about this haunting I contacted the pub and spoke to Dave Gray, who is the current landlord alongside his wife Karen. The couple took over the pub in July 2006, Dave told me "I have never seen anything myself but my wife said she saw a man sitting on the end of our bed and on another occasion she saw a man standing by the television in our room. The room above

our bedroom is closed off and there is a big double wardrobe in front of the door. The room is not used because it is still exposed to the thatch and one night we were lying in bed when we both heard heavy footsteps walking backwards and forwards in the room above us."

It quickly became apparent that there was some interesting phenomena occurring within these walls and Dave was more than happy to relate further incidences that defy a rational explanation. "Another incident was when our daughter was at home from university. She sleeps in the room next to the closed off one. She came down one morning and explained that during the night she woke up feeling very hot, so she pushed the quilt cover down and then she became really cold, but when she went to pull the quilt cover up again she found that she could not move. She told us that her arms were pinned down and that she could feel pressure on top of her. Eventually she did manage to pull the quilt back up, although she still found it difficult to move. Since then, when she has been back, she has told us that she has had the same feeling of hot and cold, but has not attempted to move."

Until recently the landlords had thought the pub was inhabited by only one spectral patron, that of old Marlow, but within the past few months this theory has been thrown into question by two visiting tourists who lead Dave to believe there maybe much more to the Harrow than he initially thought. "At first it was believed that there was just one ghost but a few weeks ago a French family visited the pub. They were over here looking for the crop circles and had got lost so decided to come in for lunch. I was talking and telling them about the various experiences I and other people have had in the pub. I am not sure of the proper description but he got out something that looked like a like a plumb bob. Anyway he got this out and held it above his hand where it rotated and according to him we have ten ghosts."

The device Dave is referring to is known as a pendulum and is meant to help those gifted in the use of these instruments to dowse for virtually anything from water to oil and even, as in this situation, to tell how many spirit presences reside in a location. Further investigation and research may well reveal more phantoms at the pub, but we will have to wait for that.

Dave continued . . . "Another couple were listening to our conversation and they told me that they had visited the pub two years earlier with their son. They said that he went to the toilet and when he came back he was as white as a sheet. When they asked him what was wrong, he told them that he had just seen a figure pass through the wall in our bottom bar."

Looking at the evidence so far, it appears that the Harrow is a ghost hunter's dreamland with so much paranormal activity being witnessed by so many

people. So does the pub get the usual host of phenomena as well, I thought? You know, the commonly reported movement of objects and so on. Well, it appears it does: "Other people have seen things move. One customer said he watched as a bottle of coke move forward on the shelf and when it reached the edge it did not tilt, it just dropped vertically. One of our barmen saw a candle on one of our tables suddenly flare up and then it flew across the room and smashed into the opposite wall."

The Harrow has it all. Great food, great ale and a plethora of ghosts, what more could you ask for? The pub can be found on the High Street, Wanborough, Swindon.

HAUNCH OF VENISON, MINSTER STREET, SALISBURY

If you're looking for a night out in fantastic and historical surroundings then your venue of choice must surely be the Haunch of Venison public house in Minster Street, Salisbury.

Apart from its great ales, fine food and great quality spirits, of both the spiritual and alcoholic variety, the Haunch is also steeped in history and claims to be the oldest public house in the whole of Salisbury. The pub's first use was not that of a hostelry, but as accommodation for the workers constructing the spire that adorns the nearby Salisbury Cathedral.

If you ascend the stairs to the small seating area, known as The House of Lords, you come across quite a horrific exhibit that one would not expect to find in a public house, take a closer look at the small bread oven in this room and you will be confronted with the remains of a mummified hand. Many years ago a man was playing a game of whist, an old trick taking card game, when it was discovered the man was cheating. His fellow card players, becoming extremely angry at the man's dishonesty, decided to cut off the cheating gambler's hand as a form of punishment for his deceitful actions. It appears to be this event that has bound one of the ghosts to the pub, for much of the phenomena experienced at the Haunch is attributed to him; the mummified hand is supposedly his and was found in the pub in the 19th century. Sudden drops in temperature and objects being moved around and hidden are commonly experienced.

This pub not only has the ghost of the unfortunate card player but also that of a woman who is referred to as the 'grey lady', a common name for many phantom women who still haunt this earthly plain. This ghost still walks the

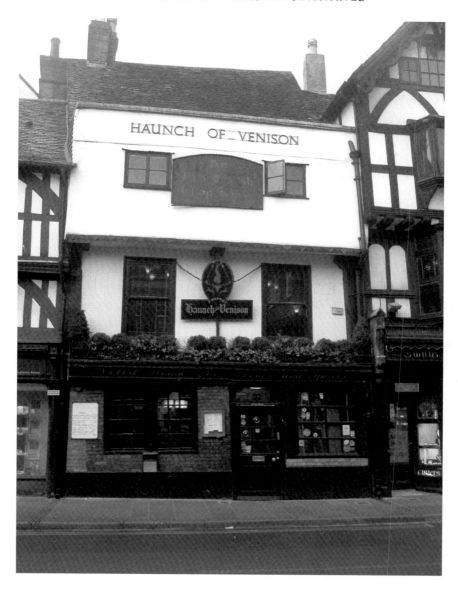

The Haunch of Venison in Minster Street, Salisbury. The home of a rather nasty act of revenge and two ghosts.

Haunch of Venison and is allegedly searching for her lost child. Her footfalls are still heard to this day.

So if these stories have whetted your appetite and you fancy a night out with a difference then why not stop off at the pub . . . you might just have your very own paranormal experience!

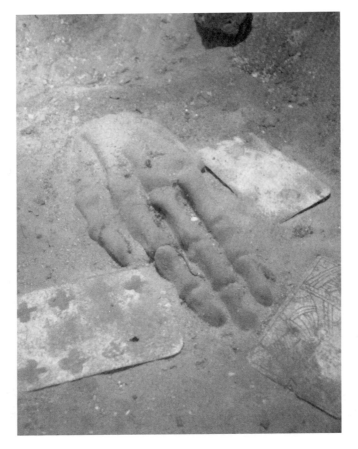

The mummified hand of the cheating card player, which can be seen in the House of Lords' room at the Haunch of Venison public house in Salisbury. Is it genuine? I'll let you draw your own conclusions on that one!

HEALTH HYDRO, MILTON ROAD, SWINDON

Unexplained knocks, raps, taps and bangs. Lights switching themselves on. Phantom music, ethereal footfalls and feelings of uneasiness are all aspects of the haunting that takes place at this health complex in Swindon.

Back in 2007 a local group, the South West Paranormal Group (www.swpg. co.uk), investigated the site in the hope of finding out what was really going on behind the ghostly experiences that people have had here. I was fortunate enough to be allowed access to the South West Paranormal Group's investigation report for this venue and they certainly had some strange things happen to them. Co-founder Emma Wright relayed to me some of their findings during the course

of their investigation and it appears the ghosts were with them from the start. "Shortly after we arrived we went for a brief walk around to get an idea of the layout of the building while Laura and Louise [two members of the SWPG investigation team] decided to stay in the mall area. On our return Laura and Louise started to tell us what they had experienced while we were gone, they had heard bangs and the sounds of doors closing, also they had witnessed a light turning on by itself, the lights in the building are not on timers and have to be psychically turned on or off. Laura and Louise were getting these responses on demand, they would call out to spirit to knock and they would get a response, they also asked for the lights to go off, and they went off, when they requested that the lights come back on they came back on."

With activity starting this early on in the investigation would it eventually fade away and the team from South West Paranormal be left with nothing for the rest of the night? In my personal experience this appears to happen a majority of the time during investigations, but in this particular situation . . . it appears not. When the team moved down to investigate the cellar one of the team members claims to have been attacked in a rather insulting and disgusting manner. As the team were making their way out of the area one of the group's members claims to have been spat on! "As he emerged from the tunnel I looked at him and I saw what I could only describe as a spit mark on his trousers," said Emma.

During the group's vigil in the cellar of the Health Hydro Centre the teams medium states that she picked up on the energy of a man who had apparently hung himself in the area, this has not yet been confirmed in the historical record, but if it is, the information from the medium certainly gives you food for thought in regards to the genuine nature of mediumistic abilities.

Jolly Tar, Hannington

The Jolly Tar Pub, on Queens Road, has had many uses over the years including stints as a farmhouse and a bicycle shop but one element that seems to remain pretty consistent over the centuries is the presence of a pub on the site, or at least a section of the building being used as a pub.

The Jolly Tar, 'tar' being an antiquated slang word meaning sailor, is named after one Captain Willes Johnson who married into the Freke family who once owned the area that the Jolly Tar occupies. In 1922 the pub was purchased by Arkells Brewery, a Swindon based company that has brewed alcohol since being founded in 1843, and has been a public house ever since.

I spoke to Roger Fessey, the current landlord, about the hauntings surrounding his pub and he had this to say on the topic of his ghosts. "To be honest I have not seen anything myself yet! I only became landlord of the Jolly Tar about nine months ago but from what I have been told I believe we have at least three ghosts haunting here." Roger went onto to tell me about the ghosts. "We have the ghost of a grey lady who sits in a large chair in the lounge bar, there's the ghost of a gentleman who apparently walks out of the fireplace and then goes round behind the bar, the strange thing with this ghost though is that he is apparently soaking wet. The last ghost is again of a woman. She appears to come out through one of the pub's windows, walks across the room and then vanishes through one of the walls. But, as I have said, I have only been here a short while so I am yet to experience anything"

For me personally, these ghosts, sitting in a chair, walking through fireplaces and windows and even walls, all sound to me to be what is termed as 'recording type' ghosts. There is a theory that people's emotions, voices, images and so on can somehow become recorded into the fabric of a building and then played back at a later time, which is why these ghosts apparently walk through walls, when these images were recorded the walls were formerly doors or routes of access and the building has recorded them doing what these people did in life and is now playing those images back, a bit like a giant tape recorder or DVD player.

Although the recording type ghost theory is commonly accepted amongst paranormal enthusiasts I feel I should point out at this stage that there is no scientific evidence to support the recording theory, more commonly referred to as the stone tape theory, but perhaps later research into this field of study may, or may not, prove or disprove this theory in years to come.

KINGS ARMS, MELKSHAM

This seventeenth-century pub is owned by the same people who, at the time of writing, also own another famously haunted pub, The Black Swan in Devizes.

Since the owners have moved into this pub there have been some unusual and unexplained phenomena that have led them to believe that the Kings Arms is also haunted.

Pam Lugg, the landlady, told me of one occurrence she had had recently whilst lying in bed. "I know the time specifically" she told me, "it was 3.15am when I saw the ghost". Most sightings of ghosts go unreported, some sightings

have an eyewitnesses statement of the date but this one has the time as well, a very rare piece of factual information that is not commonly reported.

"I woke up and looked across the room and I saw my first ever proper ghost" Pam said. "There was this ghost of a little girl. She looked like a black and white photo and she was dripping wet".

Pam, feeling somewhat disturbed at this spooky intruder, decided to hide under the quilt. She kept poking her head out of the bedclothes but the apparition was still there, the whole experience lasted for around five minutes. When the ghost first appeared Pam noted that the time was 3.15am and the ghost finally departed her bedroom at 3.20am.

Perhaps the landlords will find out who this girl is and why she haunts the Kings Arms in due course.

Kings Arms, Monkton Farleigh:

On the borders of West Wiltshire one can find the village of Monkton Farleigh, a village well worth seeking for its tranquillity and the peace that descends upon it.

The Kings Arms, the village local public house, has a rich tapestry of history and extends through the sands of time to the 11th century when a Cluniac priory was founded on the site. The priory was yet another victim that fell under the hammer of Henry VIII's dissolution of the monasteries and was disbanded in 1536.

The priory was taken apart and a house built on the site at the request of the new owner, Edward Seymour, who was the brother of the newly crowned queen, Jane Seymour. The house then passed through a series of owners over the next 300 years.

During the latter part of the nineteenth century the surrounding hills were quarried heavily for the highly prized Bath stone that the hills contained within and our first ghost comes from the time when the mining operations were in full swing. The ghost of a former miner has been spotted both at the pub and also in the road leading to the site of the mines. Another ghost, believed to be that of a Cluniac monk, also haunts the Kings Arms and the crying of an unidentified woman, who is believed to have been killed when her coach and horses crashed into the pub, has also been reported.

A local to the pub, who wished to remain anonymous, told me "you see the occasional figure moving out of the corner of your eye but I don't know if you

could just put that down to your imagination, I know the staff here get things on the bar regularly fall over on their own but whether that's because a ghost is doing it is another matter".

The Kings Arms is currently considered to be one of the most haunted pubs in the whole county of Wiltshire!

King & Queen Inn, Highworth

This public house in Highworth comes with its very own ghost!

I had the opportunity of talking to the pub's current landlord, Adam Campbell, who told me "there's certainly some weird stuff going on here, glasses smashing on their own and some people even say they have got mysterious scratches on them". The pub is allegedly haunted by the ghost of a monk who was caught stealing and then hung.

Adam continued "underneath Highworth there's a series of tunnels and, apparently, these were used by the monks. They were only discovered about 50 years ago when part of the road collapsed because of the tunnels underneath it".

Apart from people actually witnessing the ghost, of which the hot spot for this activity is the area around the toilets, there have been reports of random drops in temperature, a phenomenon that appears to go hand in hand with most ghost stories, glimpses of fleeting, shadowy figures and lights switching themselves on overnight.

The tunnels that run under Highworth are also haunted. The spectre of a woman has been seen emerging from the entrance to the tunnel and making her way towards a house in the town.

Lacock Abbey, near Chippenham

Does the name William Henry Fox Talbot (1800–1877) mean anything to you?

Well, if you were not aware of it Mr. Fox Talbot was an early pioneer of photography and thanks to his efforts in this experimental field, as it was at the time, we owe to him the positive and negative development procedures. Lacock Abbey was Talbot's family home.

The abbey started its life in the thirteenth century when it was founded as a nunnery teaching the Augustinian approach to religious life, today you can still

see the venue's monastic appearance, including the stunning cloisters that were used in the filming of *Harry Potter and the Chamber of Secrets*, but you also notice its conversion into a family home, and event which took place in 1539.

The abbey's strangest ghost must be that of the ugly little dwarf. Many years back two children, who were playing in the abbey, laid witness to the little ugly dwarf as he walked through their room. Excavations in the area, years later, revealed the skeleton of a deformed man that was concealed behind a wall in the very room in which the children had had their experience. Who is he? Why he is here and why he was buried inside the wall in the first place are perplexing questions and I am sure we will never know for certain.

The ghost of a woman has also been seen at Lacock. Her exact identity is not known for sure but she is believed, by some, to be the founder of the abbey, Ela – Countess of Salisbury or possibly it is even the lost soul of Olive Sharington, the daughter of Sir William Sharington who transformed the abbey into a family home.

LITTLECOTE HOUSE, NEAR CHILTON FOLIAT

The ghosts that haunt Littlecote House are probably the most famous in the county, but despite this, the story below nearly never made it into this book, considering the location of the house. Some references say it is in Wiltshire whilst others state it is in the county of Berkshire and would therefore have no place in a book on the ghosts of Wiltshire. None the less the story has made it!

Littlecote House as we see it today was constructed around the sixteenth century, an earlier building inhabiting the site being built around the thirteenth century. In 1560 William Darrell, known widely as Wild William, inherited the house and ran the family's respectable name into the gutter. Darrell spent large sums of money, had affairs with friends' wives and in general led quite a despicable life. His most notorious action, and the one he is remembered by, is for the summoning of a midwife that was brought to Littlecote, blindfolded, in order to deliver a baby in secret. The midwife complied and duly delivered the child but was shocked when it was seized from her arms and thrown into an open fire, the squealing baby being held down by Darrell's boot. The midwife, appalled at what had transpired, was given a bribe and told to remain silent before being blindfolded once again and led away from the house. Before the midwife left the room in which the child had been born and then callously murdered, she

tore off a small piece of cloth from the new mother's bed and had the intellect to count the stairs as she was led away from the house. Years later the midwife confessed the story and the production of the torn cloth and the number of stairs she counted, which all proved she had been in the house and therefore was considered evidence, eventually led to the arrest of Wild William Darrell.

The impressive entrance and façade of Littlecote House, a beautiful building that houses a terrible secret. Photo © Littlecote House Hotel

Being the conniving and disgusting character that Darrell was meant that he was acquitted of any wrong doing, and cash obviously changed hands in order to attain this verdict.

With such a traumatic story of a new life being born into this world and then rapidly being taken away again is it any wonder that the ghost of the midwife, maybe even the mother of the child, still haunts the house, a babe clutched firmly in her loving arms?

The Great Hall of Littlecote House. Photo © Littlecote House Hotel

William Darrell came to his death in the same way he led his life, in shock and horror. He was killed when he was thrown from his horse, some claim that the horse threw him off when it encountered the ghost of the baby he had murdered!

In 1985 Littlecote House was purchased by the English entrepreneur, Peter de Savaray. On clearing the house he put many things aside ready for auction. On the day of the auction Peter was walking in the grounds of the house when he was approached by a woman who said to him "you're a wicked man" and, with his family, he would suffer for what he has done. This obviously raised the question to Peter as to what discourtesy he had displayed to the lady and asked her so. "You have taken my baby's things," the lady replied.

After a short discussion with the lady Mr de Savary discovered a small box containing artefacts relating to a deceased child and, carrying out the ladies instructions, had the box placed in the chapel. The family lived at Littlecote for the next eleven years and always had a healthy respect for its ghosts. The house was sold to the Warner Leisure Hotel chain in 1996 and is currently a hotel. So if you fancy a night away with an added twist, and possibly a spectral encounter or two, then this is the place to stay.

There are also other ghosts that haunt Littlecote House. A black shrouded figure has been seen as well as a legion of Roman soldiers, this might seem

an implausible haunting considering the house was only built in the sixteenth century, but the site of Littlecote is also home to the Littlecote Roman villa. That explains the Roman soldiers then!

The final ghost we come to is more recent than all of the house's other ghosts. In 1922 the City Equitable Fire Insurance Company went into bankruptcy simply because one of the board of directors had been siphoning off money from the business to fill his own back pocket. Gerard Lee Bevan served a prison sentence for his crime and it seems he will serve an eternity at Littlecote House, as a ghost.

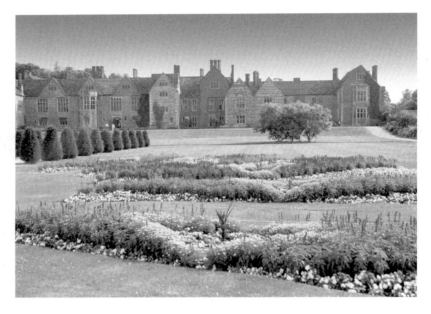

The rear of Littlecote House, pictured in the summer months when its gardens are in full bloom. Looking at the many windows in the mansion makes you wonder in which of these rooms Wild William committed his most dastardly deed! Photo © Littlecote House Hotel.

LONGLEAT HOUSE, NEAR WARMINSTER

Longleat House is without a shadow of a doubt one of the greatest gems in the crown of the county of Wiltshire.

Purchased by Sir John Thynne in 1541 the Longleat House we know today was built around 1580 after the original house, which was an Augustinian priory,

burnt to the ground in 1567. With its magnificent Venetian painted ceilings, exquisite architecture, a library containing thousands of books and many fine works of art and furniture it is easy to see why Longleat is currently considered one of the finest examples of an Elizabethan house still in existence.

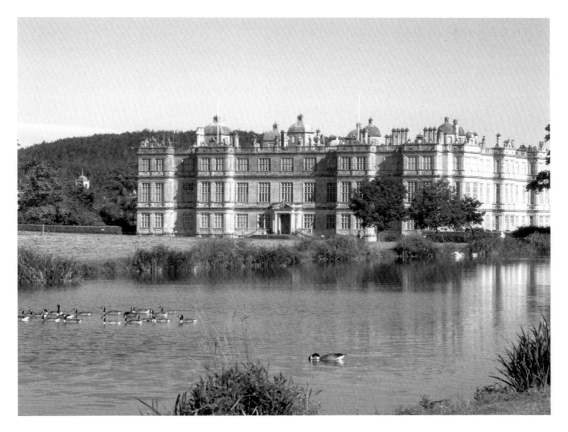

The spectacular house of the Thynne Family, Longleat. With so much history and grandeur one would expect a place of this nature to be haunted and you would not be wrong! Photo © Longleat Enterprises Ltd.

With all the pomp and history confined between the walls of Longleat it is not surprising to discover that the house is reputedly haunted. In the 1700s a lady by the name of Louisa Carteret came into the Thynne family with her marriage to the 2nd Viscount Weymouth, Thomas Thynne (1710–1751). It is said that Thomas was not the best of husbands, nor did he have the most caring of hearts, so it was not long before Louisa took herself a lover, a footman that

she had brought with her when she had moved to Longleat. The illicit affair was discovered and Thomas murdered Louisa's lover in a fit of rage, throwing him down a steep staircase and breaking his neck. Louisa herself died shortly after her lover's murder and it is said that the ghost of Louisa, dressed all in grey, still haunts Longleat and has been seen on occasions drifting around the corridors of the top passages, searching in vain for her long gone lover. Please note that after discussions with the Longleat estate I announce for the record that the ghost is known as the grey lady, due to her appearance, not green as is reported in other publications.

Other spectral inhabitants of Longleat include a Bishop who is meant to haunt the house's library and the ghosts of a Cavalier and King Henry VIII's Lord Chancellor, Cardinal Wolsey are also said to have been spotted.

LYDIARD HOUSE & PARK, LYDIARD TREGOZE, SWINDON

The ground upon which Lydiard House & Park occupies has been the site of a dwelling since the medieval era but the current house, which is of the grand

Lydiard House, Swindon, is the spectral stomping ground of the ghost of one of the house's former owners. Photo © Lydiard House & Park.

Palladian style, was built in the sixteenth century. The St. John family, at this point its worth saying that the name St. John is pronounced sin-jin, occupied this area as their ancestral home for 500 years.

One member of the St. John family still haunts their former home of Lydiard. Sir John St. John had quite a turbulent life. He was the head of the family at the time of the English Civil War (1642–1651) and was a great supporter of the Royalist cause, as were most affluent people of the time, his money and status could not protect him from the horrors of war though, for he lost three of his sons and eventually had his house and assets seized by the Parliamentarians after the Royalist cause was lost following the beheading of King Charles I (1600–1649) at Whitehall on the 30th January 1649.

The ghost of Sir John St. John has been witnessed both inside Lydiard House and in the grounds of his estate, looking very real and solid; in fact it is only his strange attire of the seventeenth century that makes him stand out from the crowd. The house is also haunted by the apparition of a woman

Saint Mary's church in Lydiard Tregoze. This church is home to the splendid memorial of Edmund St. John and also to a ghostly shrouded figure. Photo © Sophie Cummings.

who wears a white dress but there are no clues as to who she is. The smell of tobacco smoke, sensations of cold spots even though the temperature seems to be increasing and phantom music have all been reported to occur within the house.

Adjacent to the mansion is the small parish church of St. Mary's. This too is the site of a haunting, but before I come to this there is a monument to one of the St. John family inside the church that is well worth mentioning. Known as the Golden Cavalier the monument is dedicated to the memory of Edmund St. John, John St. John's son. The effigy depicts the gentleman departing from his campaign tent dressed in full cavalry armour. If you get the chance to visit the church then make sure you visit this monument as the workmanship is extremely good. The phantom that has been seen in the church is often referred to as a monk, because of its appearance as a grey, hooded figure.

MALMESBURY ABBEY, MALMESBURY

This old twelfth-century abbey is still in use as a parish church to this very day, although its appearance is now nothing compared to what it would have been like during the height of its heyday. It is good to see an active worshipping community involved in keeping the old abbey going for future generations.

Malmesbury abbey has had its fair share of unfortunate events and most of the lost parts of the building succumbed to the elements and fell down. The abbey was dissolved by Henry VIII during the dissolution of the monasteries but the place was saved by William Stumpe who purchased the abbey on the basis of turning it into a parish church, if it had not been for Stumpe's actions then Malmesbury Abbey would probably not be here today.

Considering the anguish the monks suffered under Henry VIII's plans to get rid of as many monasteries as possible, mainly to finance his wars abroad, it's understandable that the ghost who haunts the abbey is a former monk, perhaps he loved his abbey so much that he couldn't tear himself away from it when death took away his mortal remains. He has been seen wandering around the abbey's cemetery, and witnesses of other supernatural occurrences also claim that the sound of monastic singing can be heard emanating from the locked abbey. Is the ghostly monk here alone or have a few of his friends remained with him?

MANOR HOUSE HOTEL, CASTLE COMBE

The old manor house of Castle Combe, a small village located just fourteen miles from the city of Bath, really is one of those places where you feel you have stepped back in time. Much of the village has changed very little since the 14th century.

The manor house is now a very chic looking hotel hosting some fine accommodation alongside even better food and drink. It's not the rooms we come here for though, or the refreshments, but for its ghosts.

The phantom of a grey lady has been seen wandering the hotel but it is unclear as to who she is. Was she a former resident? An owner of the house or perhaps she is just a spirit in visitation?

MASONS ARMS, WARMINSTER

Even though the Masons Arms, on East Street just outside the main centre of Warminster, is surrounded by modern day take away shops you can't help but notice they appear to be from a bygone era, their Georgian facades giving away some of the clues to their real age.

Many of the shops in this area claim to have a series of tunnels running underneath them that were used by long gone smugglers. One such establishment is the Masons Arms. I spoke to a member of staff, who wished to remain anonymous because one of the historical events in the pub's history is still quite raw for some locals, who told me "Before the Masons was a pub it was a house, there's no records of a pub being here till at least 1844". With the pub being a house in the past could the ghosts that haunt here be former residents of the property? "I don't know who the ghosts are; I don't think anyone does for sure. One of the ghosts could be one of the old landladies that used to live here, it's a very sad story but she unfortunately committed suicide in the private accommodation bathroom. She shot herself"

The emotional turmoil that people attempting suicide face must be one of the most extreme emotions anyone could ever have. Perhaps the lady is still in the Masons Arms and unable to come to terms with her death, either way some very strange occurrences have happened in the bathroom where the horrid incident took place.

"The last landlady that was here called in a paranormal investigation team and that seemed to make it a lot worse. Shortly after they came and went the

lady was getting a shower when she was unexplainably scratched and pushed over in the shower." A ghost that can attack the living? I can see why other paranormal investigation groups' requests have since been declined. Would you want to risk it?

Besides this phantom shower attacker is there anything else haunting the pub? "People have seen the ghost of lady who they call Mary. Apparently she's the one responsible for throwing glasses off of the shelves. We also hear footsteps walking behind the bar area, when we are there too, but there is simply no one there . . . very weird."

"I have seen the ghost of a man upstairs. I was walking to the private accommodation when I saw this quite tall gentleman just ahead of me so I called out, thinking it was someone I knew, and he just vanished."

It seems the ghosts of the Masons Arms are not too worried about putting in the occasional spectral appearance for its inhabitants and patrons so I was particularly keen to hear of any recent sightings . . . and there has been!

"There's a building out the back called the Barn, it's a kind of little club now where people play card games and so on and last week (2nd to 8th March 2009) there were some people up there playing poker when they saw the apparition of woman walking down the spiral staircase."

With regular sightings of the pub's ghosts, glasses flying off the shelves and a ghost that attacked an unsuspecting former landlady this has got to be the place that any paranormal enthusiast should pop into for a quick drink!

Old Bell Hotel, Malmesbury

This place can hold claim to being the oldest purpose-built hotel in England. Built in 1220 by the abbot of the adjacent Malmesbury abbey, it was constructed to house the many scholars who came to the abbey to inspect, and to study, the work of the abbot at the time. Having such a high volume of people visiting him, the abbot soon decided that he needed to create a place where these visitors could stay and The Old Bell Hotel was born.

I spoke to the hotel's current director, Simon Haggarty, about some of the experiences his past guests have had. "Last year we had a guest from the United States of America staying with us, he was using the John Rushout room, and he got up in the middle of the night to go to the toilet and started to have a conversation with what he thought was his wife. When he returned to the bed he noticed his wife was still asleep. I remember the man came running downstairs

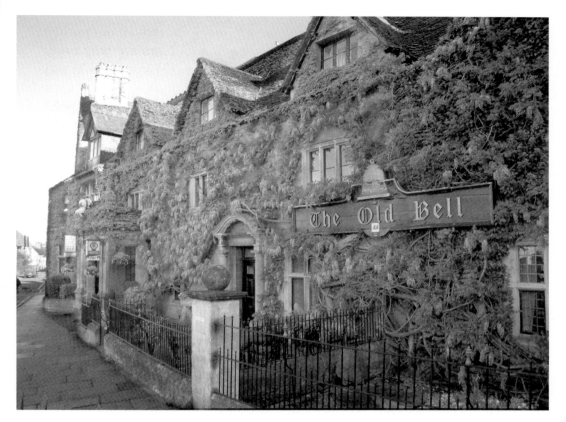

The tranquil Old Bell Hotel in Malmesbury. Photo © Simon Haggarty

in a bit of a scared state, he finished staying the night in the hotel but he checked out the following morning"

In the restaurant of the Old Bell Hotel there hangs a six foot portrait of lady, know to the staff as the grey lady, who was jilted on her wedding day. Simon told me: "she's meant to haunt here and she walks the same area that she walked when she was waiting for her husband to arrive so they could be married." It appears that this poor lady is still waiting for her betrothed to turn up and finally tie the knot. It may be this lady who is responsible for sitting on the ends of people beds whilst they sleep, a rather spooky occurrence that last happened in the summer of 2008. It's worth mentioning at this time that most of The Old Bell's ghostly occurrences happen in the east end of the hotel, this is an area that directly overlooks the adjacent Malmesbury abbey.

When I asked Simon what he thought of the haunting he replied: "I tend to take it all with a pinch of salt, I am a very sceptical person but there can be no

question that people do report weird things happening to them here. It's not surprising really as we are right next door to Malmesbury abbey and there are lots of bones underneath the hotel. In 2007 the hotel's extension was finished and we recovered quite a lot of bones and skulls from people who had been buried in what was the old cemetery."

Despite its haunting the Old Bell Hotel is a popular place to stay, and so it should be. This is a beautiful hotel with history gushing from its very foundations.

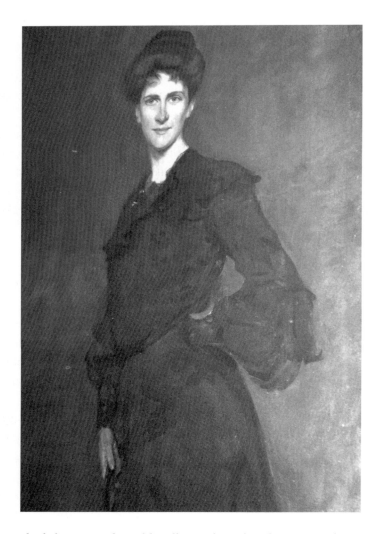

The portrait which hangs in the Old Bell Hotel. Is this the woman known to us today as the Grey Lady? Photo © Simon Haggarty.

Old Wardour Castle, Tisbury

This old and romantic castle and now nothing more than a shadow of its once grand self.

Built in the sixteenth century the castle was primarily built as a family home, and a very extravagant one at that, and secondarily as a castle to defend against invaders. The castle, even though ruined, still catches the eye of the visitor and one main thing that grabs your attention immediately is the fact that the castle is built in a hexagonal shape.

The Arundell family arrived at Old Wardour in 1544, during the English Civil War, which ravaged many a county, stately home and castle. Old Wardour was laid siege to by Sir Edward Hungerford. Unfortunately, at the time of the siege, the owner of the castle, Thomas Arundell, was away fighting another battle and he left his wife, Lady Blanche Arundell who was 61 years old at the time, to guard the castle, along with 25 retainers.

Obviously the castle's occupants were no match for the amassed Parliamentarian army, which consisted of around 1300 troops, and the castle soon fell to the invaders. Lady Blanche was arrested and eventually executed. It is her ghost that is said to haunt the remains of the castle to this day and legend states that her spectre can be seen walking towards the lake, which is only a short distance away from the castle, at twilight.

Private Residence, Ludgershall Village

Back in 2004 I, along with my team from the Hampshire Ghost Club, had the privilege of investigating a private residence in the small, sleepy village of Ludgershall. Ever since the family moved in to their home they had started to experience spectral encounters. Because the house is private I am unable to reveal its exact location.

The eldest son of the family, who later became one of my investigation team, Mr Rob Grist compiled a complete dossier of the occurrences that the family had experienced, and still do, from time to time, as they are still in residence at the house.

"We moved into the cottage on my seventh birthday, July 1978. A lot of work was needed to make this cottage our family home . . . little did we know that we had to share this house with a family who had been living there many years before we moved in, they had not moved out as they were ghosts. The ghosts of

an old man, a lady, a boy and a man in a brown cloak have all been witnessed individually, by me and my family members, visitors and the former occupants of the cottage as well.

Strange noises were heard by all, in the day time and at night, most could be put down to timber expansion and the settling of house substrates but some were not, voices would be heard sometimes, even our names were called out by these entities and yes we would answer, until we realised we were the only living humans in the house at the time.

It wasn't long before I saw my first apparition, I guess I was about 8-years-old and in bed trying to get to sleep when I saw, emerging in front of me, an apparition of an old man, hunched over, wearing a hooded cloak and leaning forward over a walking-stick.

He slowly walked towards the doorway of my mum and dad's bedroom and although his movement was very stiff it was as if the man smoothly glided instead of walking (I know that's a bit of a cliché of a ghost but that's how it was). I watched in shock until he reached the door of my parent's room and then I just screamed.

After that various things happened throughout the house, things mysteriously vanished from cupboards and drawers and would reappear, sometimes up to a year later. One evening we were all sitting downstairs watching TV when we heard a series of bangs and knocks in the bedroom above, we ran up to see what it was and the wall clock had been thrown from the wall to the floor, the board games that were on the wardrobe had all been thrown off and also laid scattered across the floor, a wall light had been pulled away from its screws and was now hanging from the electric cable.

On another late evening my father and I were watching TV downstairs when we heard the light switch click on in the hallway, we said good night as my nan lived up the other end of the house and shares a stairway with us, anyway, we heard her say good night and then we heard her footsteps going upstairs to bed, about half an hour later we heard the same light switch click, me and my father looked at each other and, simultaneously and cautiously, said good night. The reply came back to us so we called my Nan in and asked if she had gone up previously, to which she replied no. Everyone else had been in their rooms asleep so we don't know who we spoke to and had heard going to bed.

Different ghosts have been seen by other members of my family over the years. My son, when he was 2 years old, saw a boy in short trousers and braces with no shirt on, walk across the garden and then vanish, other people have also seen a small boy run through the house and vanish, a lady in a pink dress has

been seen by my sister, auntie and other visitors, who walks past the window in the back garden.

Although no apparition has been seen recently (the last being a man in brown walk across my nan's bedroom which was seen by my dad, who really didn't believe until then) voices are still frequently heard and our names are called out, often you still feel a slight touch or breath in your ear."

Considering the delightful setting in which the Grist family home lies, it is no shock to see why the idyllic cottage's former residences are reluctant to 'give up the ghost' on their very much loved, old home.

The Grist family accept their phantoms and live happily, side by side, with their co-residents.

A sketch of the ghost Rob Grist saw in his bedroom when he was a child of just 8-years-old. Sketch © Mr Rob Grist.

PUGS HOLE, NEAR BOWERCHALKE

The small village of Bowerchalke is in real threat of extinction. Like so many villages throughout England in recent years it has lost all about it that defines the place as a true English country village. You will no longer find a school here,

or a pub, or a post office, for all of them have been taken away from this small community. In fact, the last pinnacle of rural life that remains in the village is the church.

Despite the closure of the village's essential amenities Bowerchalke does have its very own ghost that no amount of politics can remove. Close to the village lies a small concave enclosure known as Pugs Hole. This area is still in use today for small music festivals, the bands that play their gigs here particularly like the acoustics of the surrounding area.

A legend tells us that many decades ago a shepherd was out on Pugs Hole when he was caught in the harsh, winter weather. Not being appropriately attired for the climate it wasn't long before the poor shepherd succumbed to the elements and perished here. Many a person claims to have heard the shepherd's painful cries for help, drifting across the countryside around this area and some even say they have seen him. A white shrouded figure drifting aimlessly along before fading away.

The actual sighting of the ghost cannot be explained away so easily, in many cases, but perhaps the sounds of the man's cries are nothing more than inclement weather whistling across the downs, which is a distinct possibility considering that the sounds, and indeed even the ghost, are only witnessed during the worst winter weathers.

RED LION INN, AVEBURY

The Red Lion Inn at Avebury is a famous haunt amongst many ghost hunters.

This seventeenth-century coaching inn has had a fair share of phenomenal experiences over the years, most of which could very well be attributed to the ghost of Florie. Florie once lived at the Red Lion with her husband. When he was called away to serve in the army during the English Civil War Florie decided to take a lover, however, the romance did not have a happy ending.

With her husband surprisingly returning from the horrors of war, he was somewhat shocked when he caught Florie and her lover together. Flying into an uncontrollable rage he shot the gentleman suitor and then slit his wife's throat (although some sources claim he strangled her). Realising what he had done, Florie's husband attempted to conceal the crime by throwing the freshly slain carcass of Florie down the well that sat in the pub.

Since that time a variety of spectral occurrences have happened at the Red Lion Inn, and not to just the staff who work there. The pub runs a highly

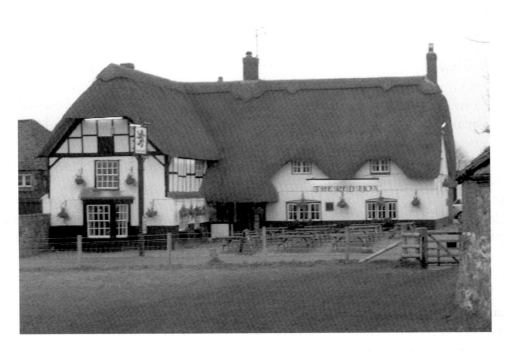

The Red Lion Inn at Avebury was the site of two alleged murders and is now home to an assortment of ghosts and their related phenomena. Photo © Andrew Marsay

successful bed and breakfast option and many people over the years have been unable to spend more than one night at the place, having been scared out of their wits during their stay at the pub. Many visitors deliberately reserve the most haunted rooms in the hope of experiencing the paranormal first-hand.

Visitors, staff and overnight guests have laid claim to witnessing the phantom of an old lady, misty figures moving around inside the pub, disembodied voices, the spirits of children playing on the landing, a man wearing a hat sitting in the bar, a lady sitting in one of the rooms apparently writing a letter, sudden cold spots and taps being unexplainably switched on and off.

Paranormal Tours (www.paranormaltours.com), a Hampshire based tour company that is run by Andrew Marsay and specialises in arranging ghost hunts at some of the United Kingdom's most haunted places, conducted a series of investigations at the Red Lion public house in both 2005 and 2006. So did the group experience anything that they couldn't explain? During one of their organised vigils in the bar Andrew and his team recounted at least one incident that they could not afford any explanation for. "One of the team saw, in the far

corner of the room, something move in the darkness. It was of a good height and broad in stature and it moved very quickly when it was spotted. We carried on, carefully watching the corner, when all of a sudden a chair fell over with no one near it whatsoever. Unfortunately this wasn't captured on camera which always seems to be the way!" Andrew said, rather disappointingly. But that wasn't the end to some of the pub's unusual activity on the night. "One final thing I recall is when we ventured upstairs for a vigil in one of the bedrooms. I remember being stood in a small hallway, when from coming from behind me I could hear a tapping noise emitting from another bedroom. On hearing this, another investigator and I ran to the door and wandered inside, nothing and no one was there. We never heard the same noise again all night." So did Andrew and his team hear the knocking and tapping of a ghost or could it have been something altogether more natural, rather than supernatural?

The inn's most impressive ghost must be the phantom coach and horses that have been seen on a number of occasions rumbling up to the pub, perhaps the coach is occupied by some ghostly passengers who are looking for a place in which to rest for the night? One room in particular that seems to be a harbinger of much of the phenomena is the Avenue Room, a room that can be hired if you wish to sleep over! People staying in this room can have a very disturbed night's rest. What with their bedclothes being pulled away from the bed and even the sensations of something, or someone, rising up through the bed upon which they are trying to sleep in.

RED LION, CASTLE EATON:

When landlady Melody Lyall first moved into the Red Lion pub at Castle Eaton she was privy to quite a collection ghostly phenomena but has told me that in recent years "things have quietened down a lot lately, perhaps the ghost has finally got used to us".

When I asked Melody if she was sure that she had definitely laid witness to unexplainable events she replied: "Yes definitely. We have had things get moved and broken, sudden changes in the temperature and even the sound of heavy footsteps on the wooden floor but the footsteps lead through an area that you can't walk through anymore."

Melody recounted an event which awoke her one night with a bit of a shake, literally. "I was asleep in bed and suddenly I felt a man's hand grab my shoulder and shake me quite violently. When I opened my eyes there was this

ghost of a man. I remember he was dressed in a coat with a very distinctive white, edged collar and he was wearing buckled shoes. He didn't have a face though." Another time the plucky landlady witnessed the same ghost again but this time he appeared to be hanging on the wall. Perhaps he was standing on the floor level known to him during his time frequenting the pub in the land of the living.

"My son has also witnessed stuff here as well. He has seen a glass move on its own in his bedroom and then the glass hit him on the head and smashed all over the bed. He also says that he has seen the ghost of a little girl and also a dog, but I have not seen those ghosts personally."

It seems that Melody isn't the only person to have witnessed the ghost of the faceless man as the former owners have also reported seeing the same apparition, who likes to frequent the top floor of the building and also one of the double bedrooms that are currently used by bed and breakfast customers. "My son has also seen the man as well and he even managed to get a photo of him but when the photo came out it was too grainy to see any detail."

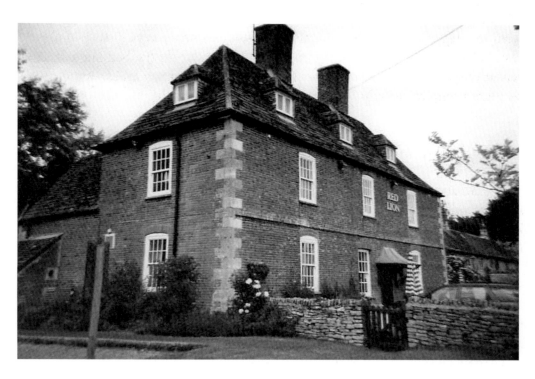

The Red Lion at Castle Eaton where landlady Melody Lyall witnessed an apparition with no face! Photo © Melody Lyall.

Although things have calmed down greatly in recent years the staff recounted an incident last Halloween when a clock flew off the wall with no apparent reason and when entering the pub's kitchen in the morning all the health and safety signs had been ripped off the wall and thrown about the kitchen. But it's not just the staff and owners who experience the paranormal in this public house, "one of our bed and breakfast customers claims to have been pinned down in his bed one night, although I must say I don't think the ghost is malevolent in any way" added Melody.

This pub certainly has some interesting phenomena occurring and it's a place where you could experience it for yourself. If you have the inkling to be pinned down in your bed or woken by the ghost of the faceless man then why not book yourself into the pub's bed and breakfast and see what you experience first hand. I would be very interested to hear of any events that occur to you.

ROSE AND CROWN, TROWBRIDGE

The Rose and Crown Pub is proud to be haunted, so much so in fact that they hold regular ghost hunts for members of the public to attend.

In recent years patrons of the pub have reported the sudden levitation of glasses resting on the bar and also the apparition of a man on the stairs. Who this man is and if he is the one responsible for throwing the pub's glasses around is not known.

ROUNDWAY DOWN, NEAR DEVIZES

Roundway Down is famous. Not for its ghosts but mainly for the crop circles, allegedly created by Unidentified Flying Objects, that have been left in the crops here since 1992.

Way back during the English Civil War a battle took place on Roundway Down which saw a victory for the Royalist forces, under the command of Lord Hopton (1598–1652), as the Parliamentarians, led by Sir William Waller (1597–1668), were defeated in what became known as the greatest cavalry victory of the entire Civil War.

But surprisingly, it is not the ghosts of soldiers slain in battle that appear to haunt the down but those of horses. During the battle of Roundway Down the Royalist forces managed to charge and drive the Parliamentarian cavalry off of

a 300 foot drop, killing the men and animals in one swift attack. The phantom horses return to the scene of their destruction from time to time.

Royal Oak, Corsham

The Royal Oak has been a place of refreshment and rest for over one hundred years and many patrons have walked over its welcoming threshold, some have never left the way the came in, for this public house is allegedly haunted by at least two ghosts.

The ghost of a man walking past the bar has been witnessed by several people but the most extravagant ghost of the pub must be the phantom lady who has been seen ascending the pub's spiral staircase, flicking her skirt as she moves up to the Royal Oak's upper floors.

When I contacted the current landlord of the Royal Oak, Nick Taylor, he informed me he was due to move on from the pub shortly but he did tell me that a series of investigations by a local, respected paranormal investigation group had recently been conducted at the Royal Oak.

Following Mr. Taylor's advice I contacted the group he told me about, the Wiltshire Phenomena Research Group. They told me that at the present time they have carried out two investigations of the property and have uncovered some unusual disturbances, including one of the team's camcorders being moved to a different area in a room, no one present admitted to changing the camera's position, well at least none of those present who dwell in the land of the living! They also experienced a key, which was resting on the bedside cabinet, move from its fixed position and was subsequently found underneath a sink the following day. The mysterious and inexplicable displacement of objects is a phenomena long connected with ghosts and hauntings.

Hayley Stevens, founder of the Wiltshire Phenomena Research Group, had this to say about the groups foray into the unknown "The Royal Oak – where to begin? The building is beautiful not only on the outside, but also on the inside too. The pub does have an interesting history, with numerous owners and numerous people who have passed through its doors, it is hard to even imagine just how many people have experienced the warm atmosphere of the building that seems alive with a character all of its own."

But what of its haunting? Did the team capture that all convincing evidence that will prove once and for all that ghosts exist? "During the investigations themselves, no occurrences took place that could not be debunked by members

of the team, so I am not overly convinced of a haunting at this location, but then . . . the key [that mysteriously moved on its own]...I don't know what to think."

Hopefully the new landlord that is due to take over the Royal Oak will be as accommodating as Nick has been in the past and more investigations are permitted to take place at the pub and who knows . . . maybe even explain mankind's biggest question – is there life after death?

SALISBURY CATHEDRAL, SALISBURY

There can be no other construction in the whole county of Wiltshire that is as awe inspiring than that of Salisbury cathedral. The cathedral can boast some impressive achievements and accolades that include having an original copy of the Magna Carta, the United Kingdom's largest cloisters, a medieval clock dating back to 1386 and the highest spire in the entire country, which stands at an amazing 404 feet (123 metres) and is the site of a flock of phantom birds that herald the death of a senior clergy member. Any visitor to the cathedral cannot fail to be impressed by the structure.

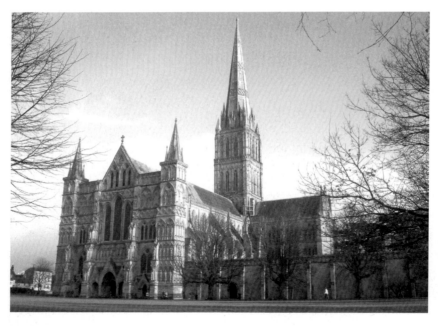

The beauty of Salisbury cathedral cannot fail to impress any visitor, but is it really the home of a phantom noose?

Once inside this great cathedral, which in 2008 celebrated its 750th year since being consecrated, you come to the tomb of Saint Osmond, which can be found in the Trinity chapel. This famed Catholic saint is not buried on his own though for he occupies his tomb with an unusual character . . . that of a murderer, Charles Stourton (1520–1557).

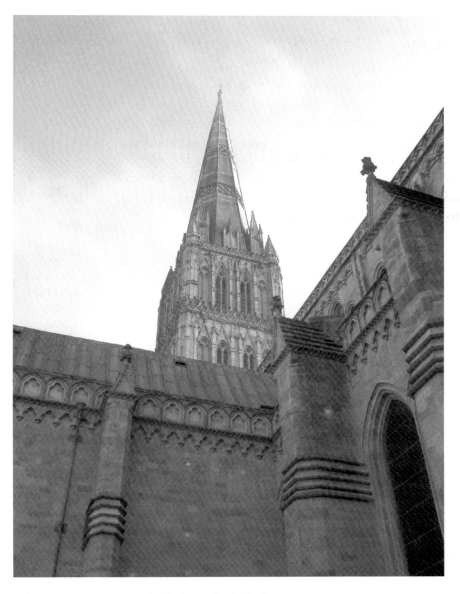

The impressive spire of Salisbury Cathedral.

Charles was the 8th Baron Stourton, a title he inherited from his father William in 1548, but his privileged upbringing did not keep him on the straight and narrow for he was condemned to death for the murder of two men. Being found guilty of the crime he was put to death by hanging in 1557. It is said that Stourton's executioner used a silken cord to hang his victim, which was a privilege bestowed on the well-to-do at the time, but when he was incarcerated into his final resting place a plain and simple noose was suspended above his tomb to remind all those who looked upon it of his crime against his fellow man.

A little over 220 years later, in 1780, the noose was finally removed but since its departure people claim to have witnessed a spectral form, resembling the noose, still hanging above the tomb before it vanishes from sight. The ghost of Charles Stourton is also said to haunt the graveyard in Kilmington with one of his victim's haunting the actual church, it certainly makes one wonder how the two gentlemen get along these days?

SALISBURY GUILDHALL, SALISBURY

The Guildhall in Salisbury, of which there have been four in total in the city with the earliest one dating back to the medieval era, was built around the turn of the nineteenth century and occupies the site of the previous Guildhall, which was known as the Council House.

In 1889 a series of cells were incorporated within its structure whose aim were to house criminals of the city who had committed crimes that were considered not too serious and these cells were in use up to the year 2000.

People working at the Guildhall have reported a plethora of paranormal and supernatural phenomena at the building that simply defies a normal, rational explanation. Sensations of being watched and a general feeling of uneasiness being claimed by many, sudden and inexplicable cold spots and unexplained noises have all been reported.

Who is it that could be creating these phenomena? There are two possible candidates for the accusations. The Guildhall's most well-known ghost is that of the white lady. She has been witnessed drifting up the stairs which lead toward the Oak Court. The Oak Court, whose appearance was copied from the Old Bailey in London, is where misdemeanour criminals were tried for their crimes but one particular Judge seemed to have a liking for passing the Death sentence on the people he sat in judgement of, clocking up a total of 28 executions for

The façade of Salisbury Guildhall, where the ghosts of a woman and a man have been witnessed.

some of the most minor crimes of the time. Perhaps this phantom white lady is one of the condemned, or perhaps she is the wife or mother of one of the 28 people sentenced to death in this room?

The second, most frequently seen, ghost is that of an unidentified man who walks the entire building but has been seen, a majority of the time, around the area of the old cells. Was he a criminal? Maybe he is a former guard? The answer to that one, I feel, with only come with continued research. Perhaps the use of psychics and mediums on investigations at the Guildhall will eventually lead to the discovery of this man's identity and the reasons as to why he stays in a place that has been the cause of so much unhappiness?

SALISBURY PLAIN, SALISBURY

When you mention the words Salisbury plain it immediately conjures up images in ones mind of the army, tanks rolling across the fields and unexploded bombs. This is a common misperception for the plain, of which the army only own approximately half of, is a place renowned for its natural beauty and amazing archaeology that the chalk plateau reveals to humanity.

Saying that though, the army certainly does have a strong presence here and should you come across one of the signs that read "Danger from unexploded shell and mortar bombs" it is probably best you turn and go back the way you came!

It's from the military that the ghost of Salisbury plain heralds from. In 1912 two airmen were testing their plane, a Nieuport Monoplane, when they banked the plane too hard and came crashing to the ground. The two airmen, Captain E.Loraine and Staff-Sergeant R.Wilson, died in the crash. The accident occurred in an area that is now well known as Airmen's Cross, a memorial marks the spot and reads 'To the memory of Captain Loraine and Staff-Sergeant Wilson who whilst flying on duty, met with a fatal accident near this spot on July 5th 1912. Erected by their comrades'.

Eye witnesses claim to have seen a spectral plane coming down near the spot where the fatal crash happened. When they go to investigate and render assistance to any possible survivors nothing can be found. No plane. No Bodies. Nothing.

Just before going to press with *Paranormal Wiltshire* another story came to light that I feel should be noted here. The story is, unfortunately, not a first-hand eyewitness account and came to me via Andrew Clarke, whose uncle knows of the legend that I now retell.

People living in and around the plain have reported seeing the apparition of a phantom horseman. The ghost gallops across the plain on his horse, sword drawn as if in full charge, when the rider suddenly falls sideways and hits the grassy plain. The horse continues on its charge and vanishes from sight.

Despite my best attempts to verify this ghost I have not been able to find any other references to a spectre of this nature although there is a chance it could be attributed to the ghost of a highwayman known as William Boulter. This could simply be a local urban legend but there could also be an element of truth to the story. Let me know if you see this ghost on your travels!

SAVERNAKE FOREST, MARLBOROUGH

Savernake Forest, 4 ½ miles from Marlborough, is said to be over one thousand years old. Savernake is a private forest currently owned by the 14th Earl of Cardigan, Michael Brudenell-Bruce, who also holds the title of 8th Marquess of Ailesbury.

Savernake is old, very old, and at one time was owned by a famous family in English history, the Seymours. Sir John Seymour was quite used to mingling with the upper crust and he regularly welcomed the king of England at the time, Henry VIII (1491–1547), who used the forest for hunting. In 1536 Henry turned his amorous advances towards Sir John's daughter, Jane. Jane married the king in 1536, becoming engaged to him the day after the execution of Henry's second wife, Anne Boleyn, who was beheaded at the Tower of London.

Jane gave the king what he always wanted . . . a son and heir, the future King Edward VI (1537–1553). Jane would not see Edward grow. Due to complications during the birth Jane died soon afterwards.

With the tragic death of Jane, so soon after the happy event of a child being born, one would think that the estate at Savernake is haunted by Jane herself, but it isn't. Instead people walking in the forest have reported hearing the sound of approaching horse's hooves that seem to pass them by. Others have seen the ghost, which is that of a headless woman, whom rides past them, on her steed, in great haste.

SLOAN'S TRACK WAY, STOURTON

Between the Wiltshire village of Stourton and the Somerset village of Penselwood runs an old track way known as Sloan's Track.

If you have nothing better to do on New Years Eve then a walk down Sloan's Track is highly recommended as you may just come across the headless horseman that haunts here.

Legend tell us that, many years ago, a man cast a wager with a friend that he could ride the distance between Wincanton Market and the village of Stourton in only seven minutes. The distance is not great and the man must have been pretty confident that he could make the journey in the allotted time.

Setting off on his trusty stead he galloped down Sloan Track. As the horse gathered speed it lost its footing and horse and rider came crashing to ground, the horseman breaking his neck with the ensuing impact.

It is said that the ghostly rider, now headless for some reason, can still be witnessed racing down the track in an attempt to win his wager.

ST. BARTHOLOMEW'S CHURCH, CORSHAM

Have you, the reader, ever heard of an elemental ghost?

They are certainly a somewhat confusing concept in the world of ghosts and paranormal phenomena as some believe they are shape shifting entities, others that they are spirits that have never lived a life on this little blue planet of ours, and others believe they are the souls of people who simply live in a different vibration frequency of existence to that of ours . . . one thing is certain though. We don't really know what they are!

However, an elemental ghost allegedly haunts this parish church. The ghost of a dwarf, barely 30 inches in height, is rumoured to haunt the area. He is considered to be quite an evil little spirit, intent on doing harm, so one to be avoided at all costs.

ST. LAURENCE CHURCH, BRADFORD-ON AVON

This church is in no doubt old but exactly when its construction was started no one can seem to fix a date and educated estimates based on architectural and historical evidence suggests the style of the church is around the 10th century, some claim the church's construction predates this and was constructed around the eighth century.

Regardless of the debate that surrounds the church's age, one thing is certain. It's haunted! A past parish priest once witnessed a group of people entering the church, nothing unusual about that I hear you say, but the priest noticed that those about to go their religious service were dressed somewhat inappropriately in the medieval style of dress.

ST. MARY'S CHURCH, PURTON

The parish church of Saint Mary's at Purton can boast more than just the grave of the famous 5th Astronomer Royal, Nevil Maskelyne (1732–1811), for it also has its own ghost!

In 1872 the skeleton of a woman, commonly thought to be that of a nun, was found concealed behind a wall in the church. The spectral appearances of a female figure in the vicinity have often led people to believe that the apparition is that of the nun but at the end of the day, no one knows for sure!

ST. MARY'S CHURCH, RODBOURNE CHENEY, SWINDON

Local legend in the area of Rodbourne Cheney gives to us the story of Mrs Dyer. Mrs Dyer stood trial, and was subsequently executed, when it was claimed that she had murdered her infant child.

Witnesses over the years have attested to seeing the apparition of the woman moving around the graveyard of Saint Mary's church, some say she is searching for her lost baby whilst others claim that she clutches the baby firmly in her arms.

ST. MICHAEL'S AND ALL ANGELS CHURCH, HIGHWORTH, NEAR SWINDON

The delightful thirteenth-century church of Saint Michael and All Angels sits upon a hill where mankind has lived for over 2000 years.

Rather unusually the ghost that haunts the church, and its graveyard, is more often spotted in broad daylight than at night. Giving the fact that during the daytime there is obviously more light available means that eye witness accounts of this apparition are quite detailed. People who have seen this ghost, his precise identity is something of a mystery, all note the same, quite scary, details, for the man has no face and just two sunken dark holes where his eyes should be.

STEAM: THE MUSEUM OF THE GREAT WESTERN RAILWAY, SWINDON

This award winning museum, based in the heart of the former Swindon Railway Works, stands as a testimony to the great and forward thinking ideas that Isambard Kingdom Brunel (1806–1859) brought to the world when he masterminded the concept of the Great Western Railway.

The museum tells more than just the story of trains though. Many personal accounts, detailing life at the time, are contained within its exhibits and brought vividly to the visitor by various life-size models going about their daily business, life size figures always tend to give any place a certain sense of a spookiness and this place is no different but it is not just the figures that make the museum feel haunted, that could also be attributed to the venue's alleged ghosts of the past!

Although paranormal investigations have taken place at the museum not much to date has been discovered. Staff members, working here late at night, have reported unexplainable temperature drops and sudden sensations of breezes passing over them. When I spoke to the museum's collections officer, Elaine Arthurs, about the museum being haunted she was somewhat confused. "As far as I'm aware there has not been any ghost activity at STEAM. However, another building on the site is famously haunted – it is occupied by English Heritage's National Monuments Record Centre. I know that various security guards have seen the ghost of a clock winder who used to wind up the main Great Western Railway Swindon Works' master clock. The clock, now at STEAM, was once at the bottom of the stairs in the main foyer area of the English Heritage building."

So with the clock that was once the epicentre for the haunting of another building could its movement to Steam have brought its ghost with it and could that ghost be the one who has been causing the sudden temperature drops and inexplicable breezes? "There certainly have not been any reports of the clock winder ghost being seen here at STEAM – I can be 100% about that one!"

So with only anecdotal testimony from a select few people we should really be asking ourselves "Is this museum haunted or not"? Perhaps time will tell?

TAN HILL, NEAR ALLINGTON

In Katherine Wiltshire's 1973 book, *Ghosts and Legends of the Wiltshire Countryside*, the author gives us a story concerning a phantom hitchhiker who was seen as early as 1904. A time way before many people had motor cars and therefore a phantom phenomenon that has not just come from the recent age of the automobile, but in fact could stretch back further than previously imagined.

Just north of the small village of Allington, in the parish of All Cannings, lays Tan Hill. You can not fail to notice the hill, what with it standing at over 950 feet above the sea level, making it the second highest viewpoint in the whole of Wiltshire.

The road below Tan Hill was the scene for at least one encounter with a spectre. In 1904 a gentleman, by the name of Alfred Fielding, was making his way past Tan Hill, with a friend, in their horse and cart. Suddenly they became aware of a woman that was standing in the middle of their path who was dressed, in what was said to be, a kind of white robe. As they approached the woman their horse started to become somewhat nervous and agitated and then, without warning, the woman just vanished into thin air.

Despite making some enquiries in the area I have been unable to find anyone else who has seen this spectral visitor. But if you have then by all means please do let me know, otherwise we could very well assume that this ghost has now finally departed this mortal realm.

THE CLIFTON, SWINDON

The Clifton public house started its life in 1878 when the building was constructed to be a purpose built hotel called The Clifton Inn. The name is now simply The Clifton as its purpose of being a hotel ceased many years ago.

The pub's history claims The Clifton is built on the site of a former priory but when I spoke to the current landlord, Simon Harrison, he was unable to confirm this fact for definite but it seems that the ghost that haunts here could be something to do with the long gone priory, for the pub is the stomping ground for a phantom nun. There have been claims by people to attest to having seen the apparition over the years, mainly in the upper parts of the building, although some reports do originate from the cellar and also, very rarely, the bar area.

Simon told me: "I have never seen any ghost here to be honest but we have had a paranormal investigation group investigate the property and their medium claims that there are more ghosts here than just the nun. The medium also said the place was haunted by a young boy who is around the area of the bottle store, ironically called the spirit cupboard, and also the ghost of a drayman."

So apart from mediums being able to use their psychic sense to detect the presence of spiritual beings in The Clifton has anyone, not of a psychic persuasion, had any unusual occurrences? It seems so.

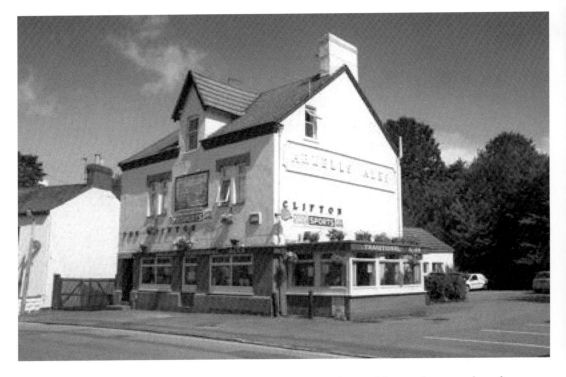

The Clifton public house is home to a spectral nun and possibly much more than first meets the eye!

Landlady Wendy Harrison has had at least one strange encounter at the pub. "I was in the bar area when I witnessed the beer pump drip tray simply jump off the side. It didn't just move a couple of inches and fall off, it moved a fair way and then dropped to the floor, those drip trays don't fall easily as they have to be lifted out of position. I don't know what could have caused that to happen!"

THE WARDROBE, THE RIFLES (BERKSHIRE AND WILTSHIRE) MUSEUM, SALISBURY

Nestling in the Cathedral Close, in the very heart of the historic city of Salisbury, lies The Wardrobe, an old thirteenth-century ecclesiastical building which was formally occupied by the clergy of Salisbury. The house passed into the hands of private residents in 1568 and remained to do so up until 1969.

In September 1978 a 99 year lease was secured on the building by the charity that now runs the The Wardrobe as a museum, and an exciting museum it is at

The Wardrobe in Cathedral Close, Salisbury, where the ghost of a former resident still haunts her old home, along with a few other phantom friends.

that with an excess of 30,000 items in its collection. Even though the museum's past residents have long left this material world some their spectral remnants remain behind as a reminder of their time in the house.

One of these past residents who have remained at their former property is that of Margaret Hussey. Mrs Hussey was born in The Wardrobe and spent virtually her whole life associated with the house, indeed she even died in it. With such a connection to the mortal world, for the love of her home must have been strong, it's no wonder that her ghost has been seen in the building.

In 1665, when the plague ravaged all of England, King Charles II came to the city of Salisbury in order to escape the horrific death that so many of his countrymen were experiencing. The king brought an entourage of servants with him that he housed in The Wardrobe. It is the ghost of one of these servants that has been witnessed many times over the years. One such reported sighting of the phantom woman, when the museum was in use as a teaching college, occurred when a group of ladies were sleeping in the regimental room and awoke in the middle of the night to find the ghostly presence standing at the foot of their beds.

The regimental room at the Wardrobe museum in Salisbury. It was in this room that a group of trainee teachers had a brush with the supernatural!

Apart from people actually witnessing the ghosts at The Wardrobe, which are undoubtedly the most impressive phenomena one can experience with any haunting, other experiences here include sudden incidences of poltergeist activity within the museum, items being moved around and hidden and sudden temperature drops and increases, sometimes upon request!

I spoke to the current curator of the museum, Colonel Michael Cornwell, who showed me around the museum and introduced me to two members of his dedicated staff that have had the occasional odd occurrence whilst busily working away at the Wardrobe. "I was working in here one Saturday night when all of a sudden I heard the sound of the window being opened directly beneath my office" said Jackie Dryden, the museum's assistant curator. "The thing that was very strange about this happening was the fact that the wall where I heard the sounds coming from no longer has a window there, there used to be one but it was bricked up many years ago. My dog has also reacted quite strangely at times as well, on occasions he seems to come over quite scared and refuses to go into certain areas of the museum."

Museum assistant Alistair Riggs showing the position of the window that was clearly heard to have been opened, despite the window being long gone. Was it a ghost opening a phantom window or have the sounds of the past somehow been trapped in the fabric of this historic building?

Museum assistant Alistair Riggs told me about the time a paranormal investigation group managed to capture something rather unusual. "They locked off an area of the museum, known as the corridor, and the team set up infra-red motion detectors and also left a dictaphone running in the area in the hope of capturing unearthly voices and sounds. When they checked back on their recordings they had got the sound of the mirror banging on the wall for a whole ninety-one seconds. No one was in the corridor and there were absolutely no draughts that could have caused the mirror to have banged so much. It's not happened before and it has not happened since. I really don't know how to explain that."

The corridor off of the regimental room. It was here that a paranormal investigation group claims to have caught the sounds of a mirror being moved by unseen hands.

TIDWORTH, KENNET

The town of Tidworth, 12 miles south of Marlborough, is famous for its military presence and also being the town in which the singer and songwriter James Blunt was born.

The town is littered with military barracks and the ghost that haunts here was once thought to be that of a highlander soldier, the ghost appears to people wearing what is thought to be a kilt, but there is more evidence to suggest that the ghost goes much further back in time, to at least the Roman occupation of Britain.

Only twenty miles to the north of Tidworth lays Silbury Hill. At over 4,000 years old it's certainly proof that the area was important to our ancestors and no doubt attracted the attention of the invading Roman army, indeed recent archaeological evidence has now pinpointed a Roman town built at the foot of this mysterious man-made hill.

With reports of Romans in the area, and the fact that there are no reported deaths of any highlanders in the vicinity, it's quite easy to draw the possible conclusion that the ghost is that of a Roman. He is reported as being very tall; some reports claim he is easily in excess of six foot. The apparition has only been seen when weather conditions are poor, why this is, I feel no one can explain.

TOURIST INFORMATION CENTRE, 31 HIGH STREET, CORSHAM

A tourist information centre is not the usual place you would expect to have a ghost but this centre, in the High Street in Corsham, is different.

Formally the home of a seventeenth-century clothier, William Arnold, the staff members working at the centre have reported a host of phantom occurrences, which they have been unable to explain. Everything from inexplicable smells of perfume to shadowy figures moving around the house and sudden drops in temperature have been reported but the weirdest phenomena that has so far been noted at the centre leaves a piece of physical evidence behind. The centre has a simple counter that records how many visitors have passed through the house during the course of its normal working day and this counter seems to tally up visitors that have never been there! Are the ghosts of the tourist information centre trying to leave a tell tale piece of evidence behind for all to notice, or could there be a mundane answer for this unusual activity?

WESTBURY SWIMMING POOL, WESTBURY

The county of Wiltshire probably has some of the strangest of haunted locations in the whole of the United Kingdom and this haunting, at the Westbury swimming pool which is owned and operated by DC Leisure Management, must be one of strangest I have come across.

The pool is said to be the oldest swimming pool in England that it is still in use to this day. It was built in 1887 with the cost of construction being borne by William Laverton, a local miller who gave the baths as a gift to the people of the town.

The ghost of a phantom swimmer, or possibly an old boiler stoker, has been seen walking the edge of the swimming pool dressed in overalls. Who is he? And why does he haunt the pool? These are the two main questions that are still waiting to be answered.

WEST KENNET LONG BARROW, KENNET

There are many historic sites in Wiltshire that exude mystery and myth and none more so than the West Kennet Long Barrow. The site is of such historical importance it is listed as a United Nations Educational, Scientific and Cultural Organisation (UNESCO) World Heritage Site.

The Barrow was built in the Neolithic period, approximately 3400 BC, with its role being that of a kind of graveyard. The barrow is currently considered to be one of the best preserved Long Barrows in the whole of the United Kingdom.

With such a rich history, plus the fact that it was the dumping ground for the dead, it's hardly surprising to discover that this prehistoric cemetery is meant to be haunted. Legend states that on sunrise on the day of the Summer Solstice, an ancient event which marked the middle of summer, a phantom priest is seen arriving at the tomb accompanied by a white dog, which sports a rather fetching pair of red ears!

WESTBURY LIBRARY, WESTBURY

With a history spanning a little over 200 years this library has it own haunting tale to tell.

The library was originally built for use as a private residence and was known as Westbury House. The Wiltshire & Swindon History Centre were able to tell

me that the house "was built by William Open in 1800 and was subsequently owned by Benjamin Overbury & then William Matravers who together ran the Angel Mill. It was purchased by Abraham Laverton around 1855 and was lived in by his family until 1888. It remained a private house until it was purchased by Wiltshire County Council in 1970 and was then converted to its present day use as Westbury Library."

But what of its haunting? I had encountered a story in which, it is claimed, a former librarian who was working at the library encountered the apparition of a lady dressed in grey. Do the current owners of the library know who this supernatural presence could be attributed to?

"The house is on three levels and it is the third floor that the ghost haunts. Apparently a servant girl was thwarted in love & took her own life. It is believed that she killed herself either in the bathroom or in her bedroom" said a staff member who didn't wish to identified.

With a life torn apart by rejection and suicide, the hapless maid is obviously a prime candidate to be the ghost that now haunts the library.

WESTWOOD MANOR, BRADFORD-ON-AVON

Despite this manor's beauty it has a somewhat terrifying history and even a curse hanging above its head. A local magistrate sentenced a gypsy for poaching, the man's wife took great offence at this and decided to place a curse over the sprawling manor and its claimed that since this alleged event took place nothing went right for the poor magistrate, nor successive occupants.

Various hideous deaths have occurred at the house. A man is said to have hung himself whilst another thought it a good idea to try and jump from the building, obviously he didn't survive the fall. Perhaps it is one of these suicides that account for the ghost of a headless man that has been witnessed in the house. Why he should appear headless is unfathomable, perhaps it is some kind of symbolic gesture of display to attest to the way the man died. But then again headless apparitions usually appear if someone has been beheaded so is the ghost of the headless man of someone yet unknown?

The ghost of a woman has also been seen on various occasions and there are no clues as to who she is.

WHITE HORSE INN, DOWNTON, SALISBURY

The White Horse in Downton, near the city of Salisbury, is a quintessentially English tavern. With its wood panelling, roaring log fire and its wall mounted, brass faced clock gently ticking away the hours in the background, this is the ideal place to come for a quiet lunchtime drink and to also soak in the ambience of this historic building.

The inn's original use, when it was first constructed, was to service the people of Downton as a centre of commerce for the local wool traders, who plied their wares here and then prepared their produce for export from the nearby port of Christchurch. Around the 1500s the inn was converted for use as a private residence for the Bishop of Winchester and less than a hundred years later, in 1599, the pub was born. Even from the exterior of the pub you are made aware of its historical connections for the stone busts of King John and his wife adorn the wall. They were both friends of Peter des Roches who founded the borough of Downton in the thirteenth century.

The current roof that any visitor can see is around 300 years old but under this roof lays another whose origins came about some 600 years ago. The medieval timberwork in the roof is considered to be some of the best preserved in the whole county of Wiltshire.

Looking out of the windows of this pub your eyes are pleasantly greeted by an array of old country cottages, and then two much more modern cottages. I spoke to the current owner of the White Horse inn, Mr. Paul Whitburn, who told me why these newish looking cottages frequent the village. "That's where the old gallows once stood. People facing charges for their crimes were condemned in the court which lies in South Lane, right next to the pub. People were brought down the lane and allowed 'one for the road' at the white horse before travelling on to the gallows and their ultimate fate."

With its long stretching history and its proximity to the village's gallows, was the White Horse as haunted as I heard it was? I was not disappointed by what the owner told me.

"When we moved in here my daughter would not settle at all. She used to wake up in the middle of the night screaming that there was an old lady sitting on her bed. After a while it got too much and one day I sat in the room and very politely thanked the ghostly lady for the care that she had shown to our daughter but also asked her to stop checking in on her as it was scaring her very much. Since that time my daughter has never mentioned the lady again" said Paul.

So had Paul's polite address to the ghost of the White Horse moved her on from the place she haunts? Probably not, but even if it did it seems that a paranormal investigation group, along with their psychic medium, discovered much more at the inn than was first thought to haunt the place.

"I remember when the medium arrived" commented Paul, "he got out of his car and he said he was accosted very quickly by a lot of ghosts. He attributed these ghosts to the people who had been led down South Lane and to the gallows. He said that there were so many spirits trying to speak to him that there was no way that he could pick out one voice in particular from the crowd."

"When the medium came to the door of the inn he said he was greeted by a man who called himself Bill. Bill said he was the innkeeper and the medium claims that Bill took him on a tour of the place. He also picked up on quite a lot of spirits from the clergy, which being a former home for bishops, is not that surprising."

So is it just mediums and psychics that pick up on the ghosts here? "Not at all," stated Paul, "my business partner has often claimed to have seen faces looking at him through the windows of the pub, waving to him, as he drives away."

"We have also had glasses fly off the shelves. We experimented with some glass tilting a while back and the question was asked to the spirit we were talking to that if they were the ones responsible for smashing the glasses could they indicate where the glasses had been thrown from. Sure enough the glass slid in both the correct directions that the glasses had been in. It was amazing, even more so as two out of the three participants didn't know anything of the glasses being smashed in the first place."

The current bar top, which literally hundreds of thousands of patron's drinks have passed across, is so old that no one can remember from where or when it arrived at the pub and the history of the pub has no record of its delivery. The hatch, through which the staff can access the rear of the bar, has an unusual quirk to it; there are two faces that have mysteriously appeared in the hatch. These faces could be nothing more than just an optical illusion, but they can be clearly seen.

The bar is an interesting area indeed, for under the heavy flagstones allegedly lies the remains of a tunnel that was used by Royalist supporters during the English Civil War, fleeing the pub when Parliamentarian troops stopped by to investigate the village. The tunnel allegedly runs underneath the River Avon and exits at the site of Moot House. Unfortunately this tunnel is just speculation, however, the truth could be discovered if the flagstones were torn up and the area inspected but Mr. Whitburn said "I'm not ready to start ripping up the floor just yet".

Paul went on to to tell me about a rather strange phenomenon he laid witness to recently. "It was about 4.30am and I was in the beer garden when I saw this strange little orange ball come out of the stable block, bounce four times along the ground and then zip straight back into the stables. It was very weird. I remember it glowed but it didn't emit any ambient light of its own." So does this unexplainable ball of light mean that the stable block is haunted as well?

"That area, the former stable block which is now our function room, is allegedly haunted by the ghost of a former milk maid. She used to sell extra favours to the gentleman, if you know what I mean. Apparently one of her customers was over charged for what he received from her and in retaliation he decided to drown her in a vat of milk."

With all these ghosts it makes one wonder how much of it is just legend and when I posed this question to Paul he simply said "none of it. This is what

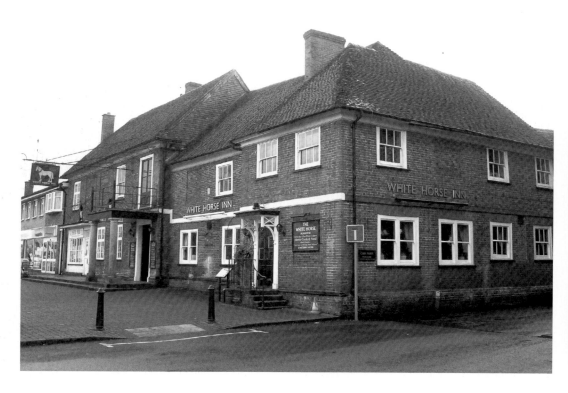

The White Horse in Downton has had its fair share of ghosts and ghouls. The current owner is happy living with his spectres in a somewhat symbiotic relationship.

has been experienced by people at the pub and also paranormal investigators looking into the pubs haunting. There are legends surrounding the village which I can tell you if you want, but I warn you they are quite extravagant."

How could I refuse this opportunity to hear some local legends from a local villager? I couldn't and with intense interest I listened on. "There's a house in the village whose roof is allegedly the upturned hull of one of Sir Walter Raleigh's ships. The other legend says that many years ago the nanny of the future Queen Elizabeth I came to stay with the infant child at nearby Barford Manor. The baby Elizabeth died whilst in the nanny's care and she fled to Downton village and stole a baby in the hope it would cover the death of the real future monarch. When the nanny got the kidnapped child back to the manor she realised she had stolen a male child to replace the dead female child. It's said that the child kept the secret all his life. This would mean that Queen Elizabeth I was actually a boy which could

The stable block where the ghost of a milk maid, who was drowned in a vat of milk, has been experienced at the White Horse.

explain why she or he never married and made such comments like "I know I have the weak and feeble body of a woman but I have the heart and stomach of a king" and "I am already bound unto an husband, which is the kingdom of England."

Obviously these stories are just legends and there could be absolutely no truth in the claims at all. However the final legend might have some truth to it and should, if at all possible, be verified.

Back in 495AD a Saxon by the name of Cerdic landed in Hampshire and claimed the English throne after he killed King Natanleod in 508AD. Paul continues the story: "It's said that Cerdic moved north into Wiltshire and set up a court in the area around Downton. He united the tribes and established a base near the area of the river Avon. I believe that this area was actually called Avalon, the mythical land often attributed to King Arthur, and that it was here and not in Somerset as is currently believed. In fact I personally believe that the English Kingdom, as we know it, actually started in what is now the car park of the White Horse inn."

These are extraordinary claims and if proved correct then they could forever change the current way in which we view the creation of the English kingdom, it would change history and maybe even prove that the myth that is Avalon was in fact true!

WILTSHIRE HERITAGE MUSEUM, DEVIZES

This museum has a fine collection of artefacts and exhibits covering Wiltshire's history and archaeology. In fact their Bronze Age collection is second to none in the whole of the United Kingdom. With this many historical artefacts you would expect that perhaps over the years a fair few haunted objects, items upon which the deceased have connected themselves too, have entered the museum's doors.

One such object is known of in the museum's collection, the desk of Maud Cunnington. Maud was famous for her archaeological exploits in Wiltshire and she conducted excavations and research at a variety of important historical sites including the West Kennet Long Barrow (which is also featured in this book).

Many witnesses claim to have seen the ghost of Maud working at her desk that now rests in the Wiltshire Heritage Museum, but not in recent years as David Dawson, the current director of the museum, told me. "There have been no sightings of her for many years, and we aren't sure where the story comes from. Perhaps she was pleased to see that her desk had come to the library where she researched much of her work."

GHOST HUNTING
AN INTRODUCTION

One of the most common questions I get asked by people wanting to conduct their own ghost hunt is 'where do I begin?'

In this brief introduction I hope to cover some of the basics. Many would-be paranormal enthusiasts out there are under the impression that in order to investigate your own haunting you need lots of expensive equipment that can take years to acquire, and although this is true in order to conduct in-depth research, there are some basic items that will help you in your quest of the paranormal.

Your first stop should be compiling an account of what has actually been occurring at your chosen haunted venue. Have there been sightings, disembodied voices, objects mysteriously moving around or sudden increases in temperature are all things that you would want to take into consideration. If a ghost has been spotted by someone at the property then try to get this witness account first hand, interview the person if possible as this will ultimately reveal the finer details of the encounter.

Once your background information on what has been experienced has been collected and organised you can then look into the history of the building and make notes of anything you consider that could be relevant. Was there a tragic death on the premises? Was there a long period of occupation by a particular resident that could explain a ghost reluctant to leave, are they emotionally bonded to the venue?

Ensure your background research is in-depth and as thorough as it can possibly be. All this information will help you at a later date and only when you have your dossier and a good working knowledge of your haunted location can your hunt begin.

When we discuss paranormal investigation equipment many people instantly rush into buying high specification digital cameras or night vision camcorders, but remember, one of the best pieces of equipment you can have is yourself, for you could be the next witness to the ghostly apparition you are investigating and your personal experience of the encounter will linger with you for years to come.

Equipment is obviously important. Purchase the best equipment you can in your price range and don't forget some very basic and essential items. Below is brief list of equipment the beginning amateur ghost hunter will want to acquire.

- Pads & pens
- Clipboard (very useful if a level surface cannot be found)
- Dictaphone (Digital preferred)
- Digital camera (Try to avoid cameras with a low mega pixel rating)
- Camcorder & plenty of spare tapes or discs
- A torch and spare batteries

Pads and pens are important for recording essential information such as the times of experiences and also at what times certain experiments were established. Remember to take plenty of pens as they have the habit of running out at the most inconvenient times!

Clipboard. In many haunted places it is very common not to be able find a flat, level surface in order to make your notes or draw maps and diagrams, this is especially so in haunted places such as graveyards and other external locations.

Dictaphones are essential if you choose to experiment with Electronic Voice Phenomena or EVP for short. Many investigators have claimed that disembodied voices have been caught on a variety of recording devices and the dictaphone has now become an essential piece of any ghost hunter's kit. Recording EVP can range from being very simple to quite complex. As this guide is only a basic introduction I will explain the simple methodology for conducting your own EVP experiment. Once you are in your chosen location, and have a specific place in which you wish to do your recording, sit down quietly and start your dictaphone recording. At the start you should always state your name, the location, the time, persons present (get everyone to say their own name so you have a record of what their voice sounds like on the recording) and also the weather conditions, stating the weather is very important as a ghostly moan on your recording may well be the sound of the wind outside if it is particularly

windy. All you need to do next is to start asking questions. There is no minimum, or maximum, number of questions you should ask and the quantity is completely up to the individual ghost hunter but remember the quality of your questions is important. You should aim at asking specific questions so that any responses gauged can be checked and as a suggestion I would include asking some of the questions below:

- Can you tell me your name please?
- Did you live here?
- When did you live here?
- Can you make three knocks, taps, raps or bangs for me please?

All of these questions could provide you with some interesting information and experiences. Remember that after you ask each question leave a space before asking your next question so that any possible ghost that may be with you can illicit an answer to you. EVP is one of the most interesting and intriguing elements of paranormal investigation and is currently unexplained even though some very plausible and possible explanations have been offered, the jury is still out and the debate between exponents of EVP continues!

When using your digital camera it is always worth taking random photos and also asking for any ghosts that maybe haunting the location to stand in front of the camera for you. I have tried this for over ten years, and although I have not had any luck with capturing that all elusive ghost, your attempts might prove more successful. There are many anomalous photographs in the public domain these days and its worth doing some in-depth research into causes and explanations for some of the most commonly caught phenomena, or what is thought to be phenomena but usually has a rational explanation.

If your going to use a camcorder on your ghost hunt then try to set it at the widest angle so you cover as much of the area in question as possible, it is always best to have more than one camera filming an area. If you manage to capture an apparition on film then the image on two cameras is obviously better than on just one. In recent years night vision camcorders have become very popular in the ghost hunting community but unless you're willing to spend in excess of £700.00 you may find your night vision rather disappointing and will probably need an additional laminator in order for your camera to film better in low level light conditions. Always use brand new tapes and never record over your old tapes even after you have transferred the film to your computer or other media.

An example of some of the author's paranormal investigation equipment, all contained in a sturdy metal case which is an essential item in order to keep your equipment safe.

A torch is always required as most people conduct their investigations at night time. This is only done so as to limit the disturbance caused by passers by and there is no reason at all why you can't ghost hunt in the daytime. In fact, some of my best results have been captured in the broad daylight hours.

I hope this brief guide, and it is by no means comprehensive, has given you some food for thought in conducting your own ghost hunt but before you go investigating I would like to offer some simple words of wisdom to bear in mind when ghost hunting!

- Have fun and don't lose sight of why you are there.
- Always get permission to investigate a location. Trespassing is illegal and gives ghost hunters a bad name so please don't do it!
- Always leave the venue in the condition you found it and take all your rubbish away with you.

- Stay calm. Many people can become quite over excited on a ghost hunt and lose their rational thought.
- Always remain objective and never jump to conclusions.
- Always take a mobile phone with you in case of emergencies and tell someone where you are going and when you expect to be back.

If you would like more information on ghost hunting or would like to attend a ghost hunt then please feel free to visit the website of the Hampshire Ghost Club at www.hampshireghostclub.net and we would be happy to put you in touch with a group in your area.

Happy Hunting!
David Scanlan

BIBLIOGRAPHY

Acorah, Derek, *Haunted Britain & Ireland* (2006)

Brooks, John, *The Good Ghost Guide* (1994)

Harries, John, *Ghost Hunters Road Book* (1974)

Inglis, Brian, *Ghosts* (1992)

Jones, Richard, *Haunted Inns of Britain & Ireland* (2004)

Kidd, C. & Williamson, D. (Ed.), *Debrett's Peerage and Baronetage* (1995)

Scanlan, David, *Paranormal Hampshire* (2009)

Sutherland, Jonathan, *Ghosts of Great Britain* (2001)

Underwood, Peter, *Ghosts of Wiltshire* (1989)

Underwood, Peter, *Guide to Ghosts & Haunted Places* (1996)

Underwood, Peter, *The A-Z of British Ghosts* (1992)

Whyman, Phil, *Dead Haunted* (2007)

Wiltshire, Katherine, *Ghosts & Legends of the Wiltshire Countryside* (1973)

Winterburn, Emily, *Astronomers Royal* (2003)

ABOUT THE AUTHOR

The author outside a haunted Wiltshire church

David Scanlan, author of *Paranormal Wiltshire*, has had an interest in the paranormal since the age of 11 when his sister started to experience poltergeist phenomena in a house she had moved to in the northern suburbs of Portsmouth, Hampshire.

In 2001, after years of researching and investigating paranormal phenomena, David decided to use his knowledge and experience and create a paranormal investigation group, The Hampshire Ghost Club (www.hampshireghostclub.net).

The group gained in popularity very quickly and established itself as a major player in the field of ghost research and investigation, a reputation it still holds today!

The group investigates allegedly haunted venues all over the UK and has conducted studies at some of England's most haunted venues including Levens Hall in Cumbria, Beaulieu Abbey in Hampshire, Dudley Castle in the West Midlands, Chingle Hall in Lancashire and many other high class locations that are notorious for their haunted heritage. David has also acted as a consultant to various organisations such as the Royal Navy, County Councils and a peer of the realm.

Members of the public have previously seen the authors work, and indeed the work of the Hampshire Ghost Club, in various publications, radio networks and TV. David starred in the first one hour special of Living TV's popular show *Most Haunted*, and also in their first ever live ghost hunt that was broadcast across the United Kingdom.

This is the author's second book. His first book, *Paranormal Hampshire*, was released in 2009 and is available from all good bookshops, online and also via Amberley Books www.amberley-books.com.

David was born in Portsmouth, Hampshire, and currently resides near Southampton with his wife and three children.

FURTHER READING

Paranormal Hampshire – David Scanlan
Amberley Publishing, 2009.
ISBN 978-1-84868-257-3

Paranormal Gloucester – Lyn Cinderey
Amberley Publishing, 2009.
ISBN 978-1-84868-249-8

Available from all good bookshops, online or direct from:

Amberley Publishing
Cirencester Road
Chalford
Stroud
Gloucestershire
GL6 8PE